IMAGES
of America

THE EASTLAND

IMAGES
of America

THE EASTLAND
DISASTER

Ted Wachholz
in association with the Chicago Historical Society and
the *Eastland* Disaster Historical Society

ARCADIA

Published by Arcadia Publishing
Charleston SC, Chicago IL, Portsmouth NH, San Francisco CA

Printed in Great Britain

Library of Congress Catalog Card Number: 2005925457

For all general information contact Arcadia Publishing at:
Telephone 843-853-2070
Fax 843-853-0044
E-mail sales@arcadiapublishing.com
For customer service and orders:
Toll-Free 1-888-313-2665

Visit us on the internet at http://www.arcadiapublishing.com

CONTENTS

ACKNOWLEDGMENTS

Writing this book really wasn't part of my plan for my life. I hated history at Elgin High School, surviving the requisite U.S. History course only with the help of my teacher (who also happened to be my football coach). As a student at Augustana College in Rock Island, Illinois, I dropped the only history class in which I enrolled. To me, history was boring, simply a bunch of names and dates that had to be memorized. But the summer of 1995 changed all of that, thanks to my friend, Pastor Eldor "Rick" Richter, and the miracle of the Holy Spirit. Rick shared Luke 12:48 with me, a Bible verse that essentially says "much is expected of those who have been blessed." I realized then and there how truly blessed I was—a beautiful wife, two wonderful children, family nearby, a nice home, job, and so forth. It was then that I also realized that much *more* was expected of me. That moment in time spawned within me the desire to grow my Christian faith and to also do something that was meaningful to others and would outlive me.

Three years later, and together with Bobbie's two granddaughters (see page eight), we formed the *Eastland* Disaster Historical Society. And now, through the collective efforts of the Society, we are delivering value to thousands of families across the country, and even the world. And, of course, my work with the Society is what led me to write this book, a book that was made possible due to the contributions of many people. I wish to thank my wife Barb (granddaughter of Bobbie); my daughter Meredith (who helped edit this book); my son Ted; my Mom and Dad; my sister-in-law Susan (granddaughter of Bobbie who also helped edit this book); my mother-in-law Jean (daughter-in-law of Bobbie); my sister Joannie; my dear aunts, uncles, and cousins (too many to list but you know who you are); Ed Eckert at Lucent Technologies, a rare historian of the utmost kind; Chip Larkin at the AT&T Archives; Mark Sorensen; Dave Bell (for his CNE support); G. E. Van Wissink (who helped edit this book); the amazing folks at the equally amazing Chicago Historical Society including Russell Lewis, Rob Medina, Colleen Beckett, and John Alderson; George Hilton (author, *Eastland: Legacy of the Titanic*); Jay Bonansinga (author, *The Sinking of the Eastland: America's Forgotten Tragedy*); Stuart Shea (author, *Wrigley Field: The Unauthorized Biography*); Stephen B. Adams and Orville R. Butler (authors, *Manufacturing the Future: A History of Western Electric*); *Chicago Tribune*, *Chicago Evening Post*, *Chicago Herald*; and Ron Steinberg. There are thousands more whom I wish to thank, and I truly wish I could name each, but I know one or more would be omitted by accident. These are the thousands of families who have personal connections to the *Eastland* Disaster—the families who have provided the names, stories, and photos of their ancestors and relatives. This book, and the Society, would not exist without your contributions. Thanks to all and to God be the glory.

Ted Wachholz
Arlington Heights, Illinois
May 2005

INTRODUCTION

Early on the morning of Saturday, July 24, 1915, with a light rain falling and the air filled with much anticipation and excitement, thousands were gathering along the Chicago River for Western Electric's fifth annual excursion and picnic that was sponsored by its Hawthorne Works employees. In fact, over 7,000 tickets had been purchased.

The S.S. *Eastland*, known as the "Speed Queen of the Great Lakes," was part of a fleet of five excursion boats assigned to take Hawthorne Works employees, their families and friends across Lake Michigan to Michigan City, Indiana, for the day's festivities. But the *Eastland*, docked west of the Clark Street Bridge on the south side of the Chicago River, never left the Chicago River. Instead it rolled into the river at the wharf's edge with over 2,500 passengers and crew members on board. Nearly 850 people lost their lives, including 22 entire families.

Describing the *Eastland* Disaster in just two paragraphs creates a temptation to look at the *Eastland* Disaster as something singular and distinct—a tragedy that occurred in mere minutes one summer morning in Chicago. But to have even the slightest chance at understanding the *Eastland* Disaster for what it really was—something utterly incomprehensible—you must include an examination of not just the tragedy, but also the event it was supposed to be (a spectacular excursion and picnic) as well as the extraordinary aftermath that followed the tragedy.

This book begins with a brief overview of the Western Electric Company and its Hawthorne Works at the turn of the 20th Century. It then explores the excursion and picnic using research from prior years' picnics. The tragedy itself is presented, including the resulting death of hundreds. The book then covers the incredible efforts to rescue, recover and provide relief to hundreds of families. This is also where the book closes—with the families and how they were affected, many in their own unique ways.

This book is the third work dedicated exclusively to the *Eastland* Disaster. By design it is a photo essay and is not intended to cover every aspect of the *Eastland* Disaster. Anyone who seeks a comprehensive work on the tragedy should obtain a copy of George Hilton's *Eastland: Legacy of the Titanic* (1995). Mr. Hilton's work is the definitive account of the tragedy, including the events leading up to the calamity, the disaster itself, and the fate of the vessel after it was raised and recommissioned as a training vessel. Anyone who seeks a historical narrative work on the tragedy should obtain Jay Bonansinga's *The Sinking of the Eastland: America's Forgotten Tragedy* (2004). Bonansinga's work is devoted to the human drama of the disaster.

In my humble opinion, this book is a nice companion piece to the works of both Hilton and Bonansinga.

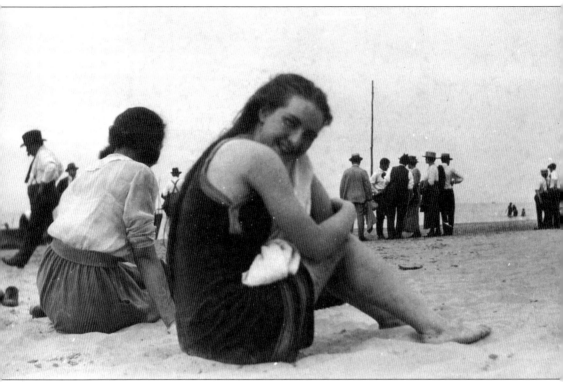

Borghild "Bobbie" Aanstad was nearly 14 years old when she experienced a day unlike any other in her life—she survived the *Eastland* Disaster after spending several hours in the water trapped between decks in the hull of the ship. The tragedy did not have a lasting affect on Bobbie—she loved going to the beaches in Chicago, Illinois, and Lake Geneva, Wisconsin. She also spoke frequently about her experiences to her family, including her two granddaughters. (Courtesy Jean Decker.)

(*Cover photo*) Shortly after the story of the Eastland Disaster broke, this photo appeared on the front page of the Chicago Evening Post. Taken by photographer Jun Fujita, this compelling photo shows the death of a small child and its impact on even the strongest of grown men. Author's note: The cover photo portrays the death of one child, but it does not reflect the extent of what is found in chapters Six and Seven. While readers may find the book compelling and difficult to put down, readers with tender sensibilities may find chapters Six and Seven somewhat unsettling. Reader's discretion is advised.

The Eastland Disaster Historical Society (EDHS)
EDHS draws its membership from throughout the country and is open to anyone interested in the history of Chicago's greatest tragedy. Please visit our web site at http://www.EastlandDisaster.org or call us toll free at 1-877-865-6295. Inquiries may also be addressed to: The Eastland Disaster Historical Society, P. O. Box 2013, Arlington Heights, IL 60006.

One

THE EARLY 1900S

"What's past is prologue."—William Shakespeare, *The Tempest*

The *Titanic*. The *Lusitania*. We all know these stories. The *Titanic* struck a huge iceberg hundreds of miles out at sea on her maiden voyage and sank in hours. The *Lusitania* took a German torpedo to her starboard side and then sank in less than half an hour. So why doesn't the *Eastland* Disaster strike a familiar chord with people, just as the *Titanic* and *Lusitania*? After all, more passengers, excluding crew members, perished on the *Eastland* than either the *Titanic* or the *Lusitania*.

Before delving into the heart of the *Eastland* Disaster, it is important to understand some of the basic historical issues connected to it—from the *Titanic* and the *Lusitania* to Wrigley Field and the World's Fair. While this chapter will not analyze the social, economic, political, and cultural aspects of the early 1900s, it will bring certain events back to the forefront of your consciousness. Not only should this help you to recall some of the basic historical issues of the time, but I hope it will also raise your curiosity. Almost all of these events are connected to the *Eastland* Disaster.

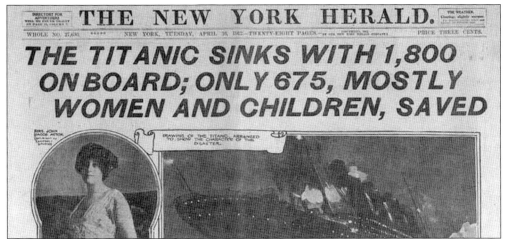

The unsinkable *Titanic* struck an iceberg and sank on April 14, 1912. Newspapers around the world headlined the story. Lifeboat capacity became a major issue as hundreds of passengers and crew went to their icy, watery graves even though they had hours to escape. The headline "Mostly Women and Children Saved," while true for the *Titanic*, was not the case for the *Eastland*. (Courtesy Library of Congress, Serial and Government Publications Division, 53.1.)

Edward F. Dunne, a former mayor of Chicago, was elected Governor of Illinois in 1912 and served until 1916. He was in San Francisco attending the 1915 World's Fair when the *Eastland* Disaster occurred. (Courtesy the Historical Society of Oak Park and River Forest.)

In June 1913, Governor Dunne signed the bill giving women in the state of Illinois the right to vote for Presidential electors and some local officials. However, women still could not vote for state representative, congressman, or governor; and they still had to use separate ballots and ballot boxes. But by virtue of this law, Illinois had become the first state east of the Mississippi to grant women the right to vote for President. The women celebrating the granting of women's suffrage in Illinois are from Western Electric's cable plant. (Courtesy Ron Steinberg and Lucent Technologies Inc./Bell Labs.)

In 1913, President Woodrow Wilson entered into the first of his two terms as President of the United States. Two years later he would have to deal with two major ship tragedies. (Courtesy Library of Congress, Prints and Photographs Division LC-USZ62-20570.)

Wrigley Field, originally known as Weeghman Park, was completed in 1914 and was home to the Federal League's Whales for the 1914 and 1915 seasons. It became home to the Chicago Cubs in April 1916. (Courtesy Chicago Historical Society, *Chicago Daily News* negatives collection, SDN-059261.)

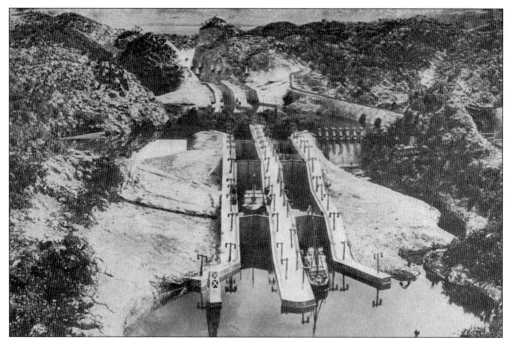

Started by a French company in 1881, the Panama Canal through the Isthmus of Panama was completed by the United States in 1914. It was a transportation breakthrough—the "kiss of the oceans"—connecting the Atlantic in the east with the Pacific in the west. (Courtesy *Eastland Disaster Historical Society*.)

Nearly 4,000 telephones, together with switchboards, power plants, cables, and other telephone apparatus, were installed in and around the Panama Canal Zone by the Western Electric Company. Several months later, in January 1915, Western Electric would play a significant role in the communications breakthrough that rivaled the importance of the Panama Canal—connecting the telephone systems (and their subscribers) from the East Coast to the West Coast. (Courtesy Ron Steinberg and Lucent Technologies Inc./Bell Labs.)

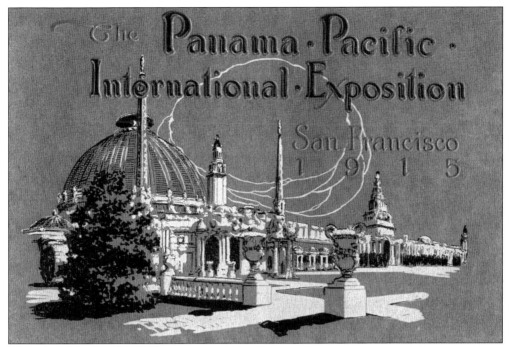

The 1915 World's Fair (officially named the Panama-Pacific International Exposition) was held in 1915 in San Francisco, California. The Expo was a year-long celebration of the opening of the Panama Canal with many attractions to entertain visitors, including bi-plane rides over the San Francisco Bay. (Courtesy *Eastland* Disaster Historical Society.)

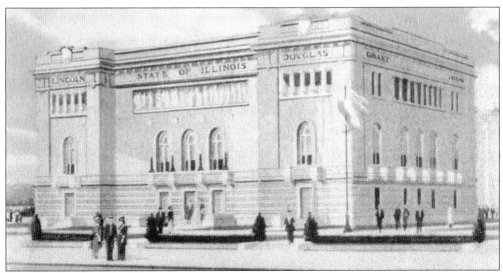

Every state in the Union that participated in the Expo constructed a building representing them; festivities were planned for each state to showcase itself. Many Illinois dignitaries, including Illinois Governor Edward F. Dunne and Chicago Mayor William Hale Thompson, were in San Francisco and had rehearsed their keynote speeches in preparation for the State of Illinois festival, which was scheduled to commence Saturday morning, July 24, 1915. (Courtesy *Eastland* Disaster Historical Society.)

William "Big Bill" Thompson was elected mayor of Chicago in the spring of 1915. Mayor Thompson, along with Governor Dunne, was attending the World's Fair in San Francisco at the time of the tragedy. (Courtesy Chicago Historical Society, *Chicago Daily News* negatives collection, DN-064415.)

On May 7, 1915, a German U-boat torpedoed the British passenger liner *Lusitania* off the coast of Ireland. America recoiled at the loss of 1,198 passengers and crew, including more than 100 Americans. President Woodrow Wilson issued a blazing response to Germany for the sinking of the *Lusitania*, holding them responsible for the loss of American lives. Wilson could never have envisioned that he would be dealing with a second ship disaster of a similar magnitude, but on the safe waters of his home country, less than three months later. (Courtesy Library of Congress, Prints and Photographs Division LC-USZ62-64956, LC-USZ62-64957.)

Two

THE BELL SYSTEM

"I can see the time when every <u>city</u> will have one."
—An American mayor's reaction to the news of the invention of the telephone.

In the 1800s, the railroad and telegraph were important links of communication across the United States. Toward the end of the century and into the early 1900s, the telephone was beginning to play an important role as well. At first, the telephone was the voice of the community. As the population increased and communities stretched to the corners of the country, the telephone faced a much larger task: connecting the communities and people regardless of distance. American Telephone and Telegraph's (AT&T's) president, Theodore N. Vail, shared his prophetic vision of coast-to-coast "universal service." In 1909, and in support of Vail's vision, AT&T's Chief Engineer John McCarty promised that universal service would be ready by the opening of the Panama Canal, even though the technology to do so did not exist at that time. The Bell System would provide the means to that end.

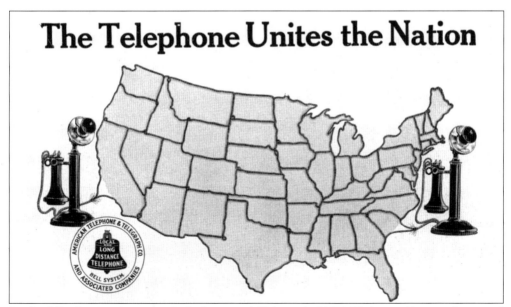

In the fall of 1908, American Telephone and Telegraph (AT&T) first made use of national advertising to tell the story of the Bell System as an institution of American life. The theme of the advertising was "one policy, one system, universal service." (Courtesy Ron Steinberg and Lucent Technologies Inc./Bell Labs.)

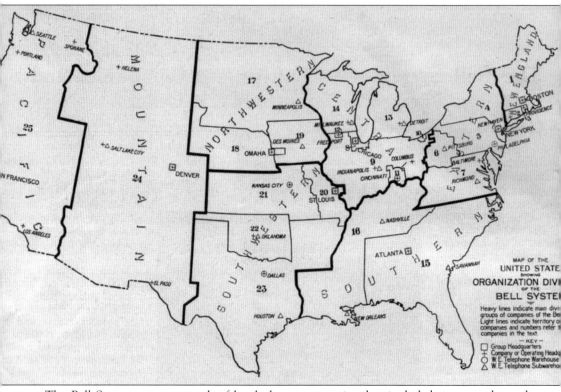

The Bell System was a network of local phone companies that included, among others, the Chicago Telephone Company. These companies were affiliated with or owned by AT&T, and their phone systems were linked by AT&T's long distance network. The equipment for the Bell System was provided by the manufacturing and supply capabilities of the Western Electric Company. The implementation of Vail's vision of coast-to-coast universal service would be the Transcontinental Line. (Courtesy Ron Steinberg and Lucent Technologies Inc./Bell Labs.)

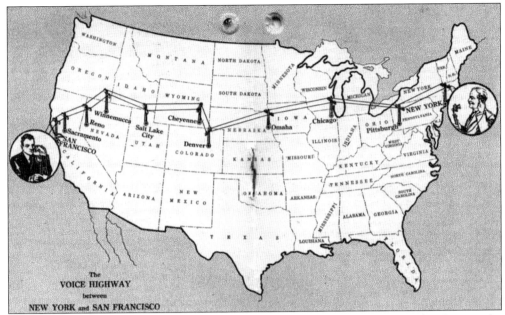

The Transcontinental Line crossed 13 states and was carried on 130,000 poles. Joining the Atlantic and the Pacific, the Transcontinental Line connected 100 million people over nine million telephone stations. It was an incredible achievement for AT&T, the Bell System, and Western Electric. A sentence spoken by a person in New York, without the aid of a telephone, would travel at the speed of sound and would take four hours to be heard in California. The same sentence, traveling over the Transcontinental Line, would take 1/15th of a second. The Transcontinental Line brought together the subscribers of the 25 Bell operating companies and thousands of local companies. (Courtesy Ron Steinberg and Lucent Technologies Inc./Bell Labs.)

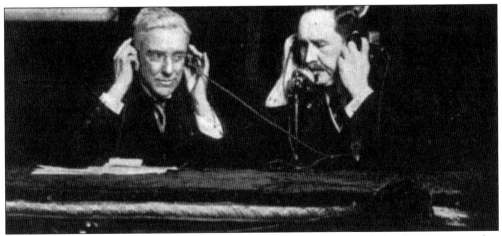

On January 25, 1915, the first transcontinental telephone call was made by the same men who, nearly 40 years earlier, had made the original telephone call on January 25, 1876. Speaking from New York City, Alexander Graham Bell spoke to Dr. Thomas A. Watson (left) in San Francisco the words he used in 1876: "Mr. Watson, come here, I want you." In 1876, the two men were but 100 feet apart. This time, 40 years later, these two telephone pioneers were 3,000 miles apart. The benefits to commerce and society of the Transcontinental Line rivaled those provided by the opening of the Panama Canal. (Courtesy Ron Steinberg and Lucent Technologies Inc./Bell Labs.)

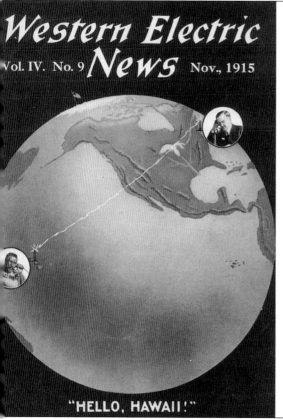

Western Electric News
Vol. IV. No. 9 — Nov., 1915

"HELLO, HAWAII!"

Western Electric News
Vol. IV. No. 9 — Nov., 191[5]

"HELLO, PARIS!"

Months later, on September 29, 1915, the first coast-to-coast wireless conversation was held between New York and California. The conversation was heard in Honolulu, Hawaii as well as Paris, France. The Western Electric Company and its quality telephone equipment made all of these achievements in communication possible. It was an exciting time for the country, the world, and Western Electric. (Courtesy Ron Steinberg and Lucent Technologies Inc./Bell Labs.)

Three
THE WESTERN ELECTRIC COMPANY

"Family Owned and Operated"

The seeds for the Western Electric Company actually sprang forth from the telegraph, not the telephone. And whereas Western Electric became most noted over the years for its quality telephones and telephone systems, it also spent considerable time and resources as a distributor of electrical appliances. Yet those who knew Western Electric from the inside knew that it wasn't a particular product line—telegraph, telephone, electrical appliance or other—that was the essence of the company. Rather, at the heart of Western Electric was its all-out belief in and commitment to a simple concept—make things well. It was often stated that the Western Electric standard in its manufacture was PERFECTION. This approach made it the pre-eminent manufacturer of high-quality products. Western Electric applied this same approach—or perhaps attitude—to the workplace, making it the pre-eminent employer known for its high-quality work environment that was "like family."

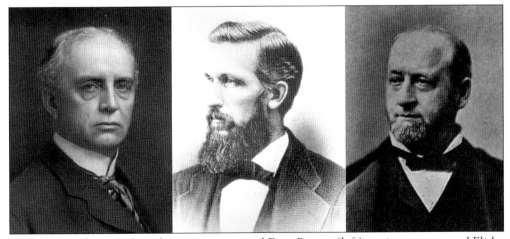

An honest and paternalistic businessman named Enos Barton (left), an inventor named Elisha Gray (center), and a capitalist named General Anson Stager pooled their respective strengths (and cash) to organize Gray & Barton, whose principal product initially was telegraph apparatus. A few years and several business acquisitions later, it would become the Western Electric Company. (Courtesy Ron Steinberg and Lucent Technologies Inc./Bell Labs.)

In 1869, the new firm of Gray & Barton was one of many firms competing in the telegraph apparatus business. Two years later, Gray & Barton was fortunate enough not to be destroyed by the Great Chicago Fire. Their business actually accelerated as a result of the fire. (Courtesy Ron Steinberg and Lucent Technologies Inc./Bell Labs.)

In 1872, the Western Electric Manufacturing Company was formed from Gray & Barton (which ceased to exist). The Western Electric Manufacturing Company soon became a key manufacturer in the new communications empire—the telephone. Nearly a decade later, and after the industry-wide battle over the telephone patent had been settled, a new company emerged—the Western Electric Company. AT&T held a majority interest in the stock of the new company. Under the new arrangement, the new Western Electric Company became the <u>exclusive</u> manufacturer of telephones for AT&T. (Courtesy Ron Steinberg and Lucent Technologies Inc./Bell Labs.)

In the early part of the 20th Century, and with Western Electric well established in the telephone business, Enos Barton recognized that electricity was still in its infancy, with enormous potential for additional fortunes to be made. As a result, and in addition to its telephone manufacturing and distribution, Western Electric became one of the largest distributors of electrical apparatus. Its product lines included dishwashers, fans, vacuum cleaners, toasters, irons, washers/wringers, lamps, and numerous other electrically powered appliances. (Courtesy Ron Steinberg and Lucent Technologies Inc./Bell Labs.)

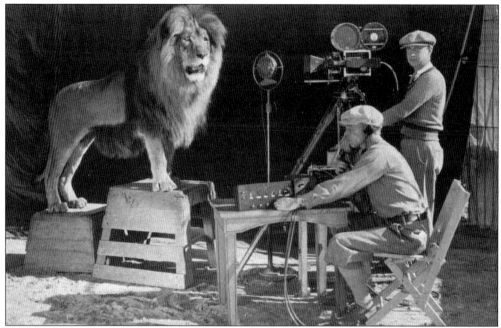

Western Electric subsequently invented the loudspeaker and successfully brought sound to motion pictures. The Metro-Goldwyn-Mayer (MGM) lion, which appeared as the trademark for all pictures made by that company, would later roar from movie theatre and home television screens, courtesy of high quality Western Electric sound equipment. (Courtesy Ron Steinberg and Lucent Technologies Inc./Bell Labs.)

Chicago Mayor William Hale Thompson awarded to Western Electric the contract covering incandescent lamps for various locations within the city of Chicago, including its new Municipal Pier. Although the Western Electric electrical appliance businesses were successful, the company would eventually abandon these businesses to focus on telephone manufacturing and supply. The business of making telephones would be concentrated at its massive Hawthorne Works facility. (Courtesy Ron Steinberg and Lucent Technologies Inc./Bell Labs.)

Four
THE HAWTHORNE WORKS

"Bigger Than Al Capone"

The Hawthorne Works was Western Electric's largest facility. Its campus rested on over 200 acres in Cicero, Illinois. It was a city within a city, having its own hospital, fire department, water tower and supply, railroad, power house (independent electrical supply) and fuel storage. The plant's departments included telephone apparatus, installation, cable and wire, manufacturing, engineering, and inspection. In addition to significant spending on the manufacturing capabilities of the Works, management at Western Electric and the Hawthorne Works also invested heavily in establishing a culture that was "like family." In support of its paternalistic, family culture, Hawthorne Works had its own gymnasium, band shell, company store, restaurant, library, and social clubs. A baseball diamond, track and field grounds, and even bowling alleys helped to encourage competition in athletics.

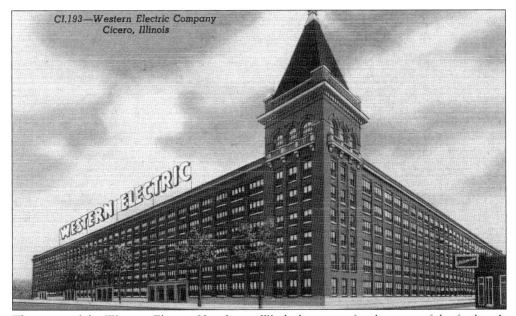

The tower of the Western Electric Hawthorne Works became a familiar icon of the facility. It was located at the southeast corner of Cermak Road and Cicero Avenue, before being leveled in the 1980s to make room for a shopping mall. (Courtesy *Eastland* Disaster Historical Society.)

Western Electric valued athletics as a means to promote acquaintance and fellowship among employees. Company officials felt "it was easier to do business with a man whom you knew than one whose personality was an unknown quantity." The track, field, and alley offered an excellent medium for all employees to become better acquainted with each other. Athletics at Western Electric provided enjoyment, promoted a healthy rivalry between the various departments, and brought employees into close individual contact away from the job. All of this was carried back into the shop or office where it made for better personal feelings among employees and smoother teamwork. Athletics at Western Electric were diverse and included track and field events of every sort, wrestling bouts, baseball, golf, soccer, football, tennis, bowling, fishing, gun clubs, and even chess and checkers. (William Watson, Western Electric employee who narrowly missed boarding the *Eastland*, back row, far left; donated by the Kolin family; courtesy *Eastland* Disaster Historical Society.)

Western Electric valued education. Evening classes of every sort, directly related to work and otherwise, were offered and well attended. Hundreds of employees, men and women alike, participated in the Hawthorne Club evening classes. (Courtesy Ron Steinberg and Lucent Technologies Inc./Bell Labs.)

Western Electric valued entertainment for the same reasons that it valued athletics and education. True to everything Western Electric did, entertainment at the Hawthorne Works was done in a big way. Thousands attended the annual banquet of the Hawthorne Works employees, shown here at the LaSalle Hotel in Chicago. Other forms of entertainment available to employees included the Western Electric band, orchestra, roller skating masquerades, ice skating, moving picture shows, dances, and for the men—smokers. The paternalistic, family-like approach was not a façade, it was earnest and sincere. One Hawthorne Works employee wrote in March 1915: "You can buy a good meal anytime for a couple of dollars. What you won't get with it though is Hawthorne good fellowship. That can't be obtained outside [of Hawthorne]. The whole vast product is exclusively for Hawthorne consumption. It is given away lavishly but you can't buy it at any price." (Courtesy Ron Steinberg and Lucent Technologies Inc./Bell Labs.)

The family atmosphere so typical at Hawthorne Works was enriched by the fact that most employees were neighbors at home as well as co-workers at the shop or office. Ethnicity was another common denominator that helped galvanize relationships among employees. The majority of Cicero residents in 1915 were first- or second generation immigrants, predominantly Czech and Polish. While many commuted to work from Chicago and the communities of Morton Park, Berwyn, LaGrange, Oak Park, Riverside, and Austin, many Hawthorne Works employees lived within a mile or less of the Works. Rows of cottages were within a 15-minute walk of the Hawthorne Works; rent was $15-$20 per month. The house pictured was in Morton Park, a ten-minute walk from the Works. Raising animals at home—including cows, horses, chickens and goats—was common. (Courtesy Ron Steinberg and Lucent Technologies Inc./Bell Labs.)

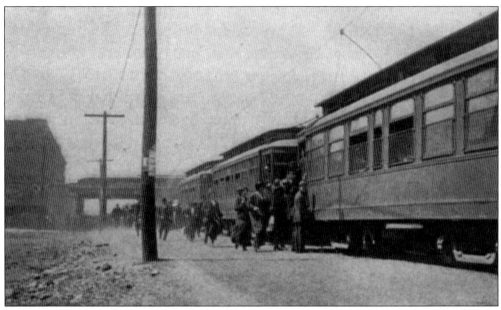

Commuters to Hawthorne Works had a variety of transportation choices. Streetcar lines—including the Twenty-Second (Cermak) Street, Ogden Avenue, and Forty-Eighth (Cicero) Avenue lines—ran directly to the Works. For five cents an employee could commute from Chicago and transfer to one of the streetcar lines that stopped at the Works. The surface and elevated trains provided additional routes including the Garfield Park, Douglas Park, and Chicago & Oak Park lines. (Courtesy Ron Steinberg and Lucent Technologies Inc./Bell Labs.)

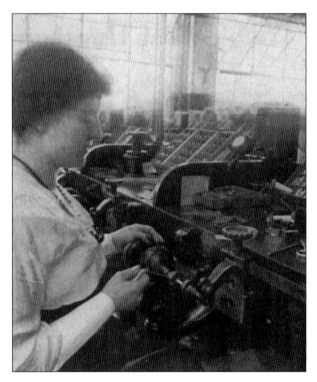

Western Electric valued the role of women, even before the days of women's suffrage. Women played a key role in all aspects of life at the Hawthorne Works including the manufacturing areas. The "natural delicacy of touch and carefulness" of women made them much better than men at performing intricate tasks such as coil winding. Women played critical roles in other areas, too, including engineering and in growing the Western Electric family culture. The Hawthorne Women's Club was organized in late 1912, just one year after the Men's Club was organized. The Women's Club ensured participation in athletics, education programs, and entertainment at Western Electric—including employee picnics. (Courtesy Ron Steinberg and Lucent Technologies Inc./Bell Labs.)

Five

THE ANNUAL
EXCURSION AND PICNIC

"All in a summer's day."—Rosemary Pietrzak

Summer entertainment for many people in the 21st Century is varied, with many things being taken for granted: watching any baseball game across the country on satellite television; CD and DVD players, computers, the Internet, iPods, Xbox, and PlayStation; a routine flight on a jet, perhaps to Disneyworld or for the more exotic, a Caribbean island, Europe, or Asia. Summer entertainment in the early 1900s for many people in the Midwest involved a horse-and-buggy or train ride to a local wharf for a cruise on one of the Great Lakes. Western Electric's company philosophy of "make things well" extended not just to its manufacturing capabilities but also to every aspect of work—including employee picnics. The 1915 picnic was organized by the newly formed Hawthorne Club (created when the Men's Club merged with the Women's Club on April 23, 1915). These incredible events did not just happen by accident; they were carefully planned and organized.

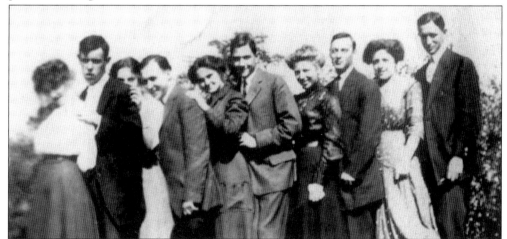

Hawthorne Works' employees not only worked side by side, they played on sports teams, went to night school, attended the same churches, and lived as neighbors in the same communities. Many shared the same primary language, which frequently was something other than English. There was one more thing that was shared: they all looked forward to summertime and the annual excursion and picnic. It was said throughout the Works that "summer was invented… especially for the annual picnics of the Hawthorne employees." (Bertha Wintermute, Western Electric employee and *Eastland* Disaster survivor, second from right; courtesy Susan Baysinger.)

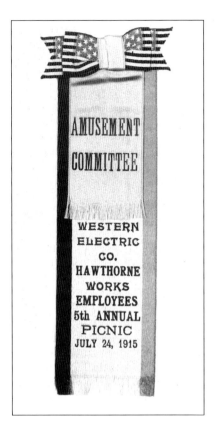

The first four Hawthorne Works' employee picnics, held 1911 through 1914, were organized by social committees and clubs of employees. For the 1915 excursion and picnic, numerous committees were formed and employees were encouraged to be part of the planning process. Opportunities abounded for virtually everyone on a wide variety of committees, including: Program, Judges, Prizes, Beach, Dancing, Tug-of-War, Central, Honorary General, Amusement, Picnic, Transportation, Tickets, Photographic, Reception, Grounds, Publicity, Music, Athletics, and Races. (Property of AT&T Archives. Reprinted with permission of AT&T.)

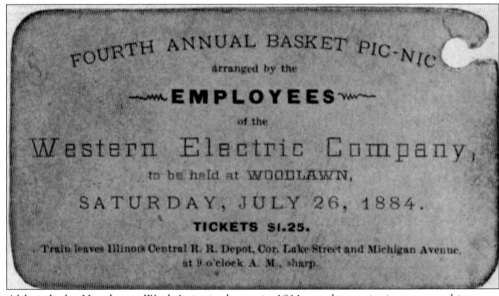

Although the Hawthorne Works' picnics began in 1911, employee picnics were nothing new to Western Electric. (Courtesy Ron Steinberg and Lucent Technologies Inc./Bell Labs.)

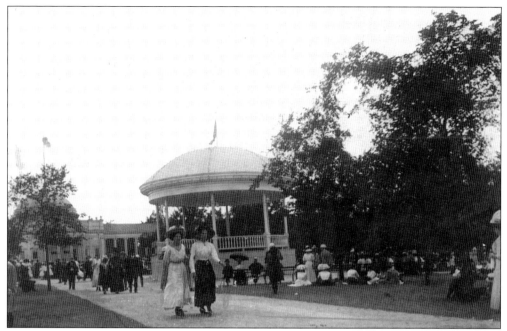

Michigan City was the ideal location for the Hawthorne Works employee picnic. Its showcase feature was the lakefront Washington Park, which offered various attractions including a roller coaster, electric merry-go-round, dancing pavilion, picnic grounds, baseball park, bathing beach with bath houses, band stand, bowling alleys, amusement park, and photo studio. (Courtesy LaPorte County Historical Society, Indiana.)

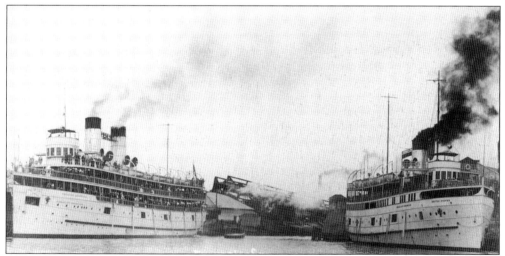

The picnickers numbered in the thousands for each of the excursions and picnics. Each picnic required several large excursion ships to move the mass of people across the lake. The Transportation Committee made arrangements for the excursion by contracting with the Indiana Transportation Company, which chartered enough ships to move the throng of picnickers to Michigan City. The *Theodore Roosevelt* (left) and the *United States* (right) were two of the ships used in each of the first four picnics. Other ships used over the years included the *Holland*, the *Pere Marquette*, and the *Eastland*. (Courtesy LaPorte County Historical Society, Indiana.)

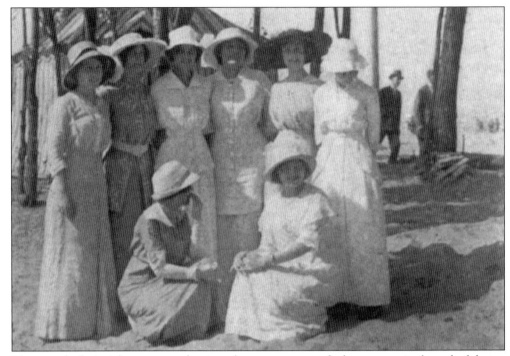

The crowd of picnickers was predominantly young, many of whom were single and of dating age. The girls would dress to "the nines." Wide-brimmed hats, pretty, long dresses, stockings, corsets, and fancy boots and shoes were worn—all on a warm summer's day. (Courtesy Ron Steinberg and Lucent Technologies Inc./Bell Labs.)

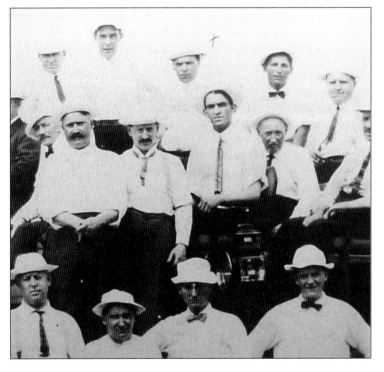

The men, many of whom were also young and single, would dress in their "Sunday best" as well. August Nelson, a musician who played in the Hawthorne Works band, stands in the back row, center (marked by the 'X') at one of the employee picnics. August never returned home from what was to have been the fifth annual excursion and picnic. (Courtesy family of August Nelson.)

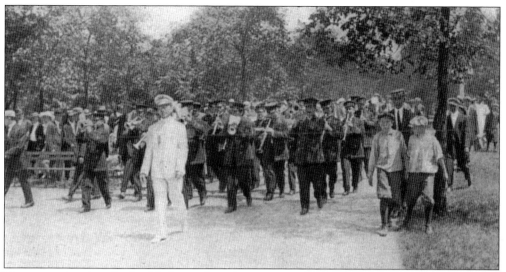

Upon arrival at the wharf in Michigan City, the excursion ships would discharge the picnickers on Trail Creek, just to the west of the Franklin Street Bridge. From here, the picnickers had immediate access to Washington Park. The first detachment of picnickers who arrived was led into Washington Park in a grand procession led by the Western Electric Band. The music continued throughout the day, with dancing—including a tango contest—in the pavilion. Soon after the grand procession reached its destination, the crowd scattered to seek out the attractions that appealed to them most. (Courtesy Ron Steinberg and Lucent Technologies Inc./Bell Labs.)

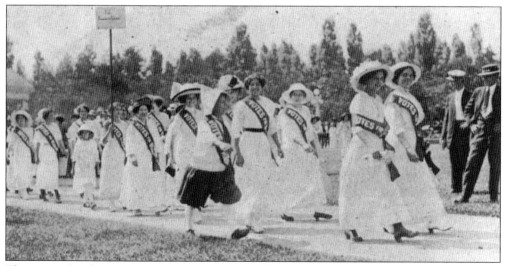

There was also the women's parade, "composed of all the pretty women in the plant (which, of course, meant *all* of the women) arranged in companies according to departments. Almost anybody could talk a week about that parade alone." Shown are the "window smashers" from the cable plant. (Courtesy Ron Steinberg and Lucent Technologies Inc./Bell Labs.)

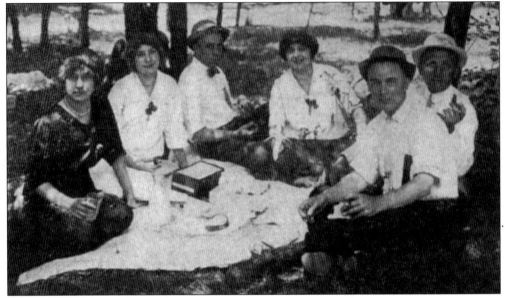

For many, a day at Washington Park meant a day off of work (in the early 1900s, employees worked a six-day work week), to be enjoyed by nothing more than rest and relaxation. Husbands and wives enjoyed the serene wooded sections of the park—away from it all—while engaging in peaceful conversation with their co-workers, friends, and neighbors. It was a simple time, and the plan for the day was just as simple: "The women furnish the beauty; the men bring their appetites." (Courtesy Ron Steinberg and Lucent Technologies Inc./Bell Labs.)

For those who did not wish to make their own lunches, walking across Trail Creek and into the central business district of Michigan City was an option. Many of the local businesses, including restaurants such as Vreeland's and Tyrell's, welcomed this day and the large number of patrons it brought.

"The excursionists are composed of a fine lot of people—orderly, good looking, and are just the kind of people whom it is a pleasure to have visit us."

(Excerpt from the *Michigan City Evening News*.)

The picnic also presented the predominantly young 20-something crowd with great opportunities for showing their affection and interest for one another. "Bring along the wife you have (if you have one) or the wife you are going to have (if you have none)," proclaimed the advance promotions for the picnic. It is difficult to determine from this photo whether this couple is married, betrothed, or just single and dating—but they are obviously in love. (Courtesy Ron Steinberg and Lucent Technologies Inc./Bell Labs.)

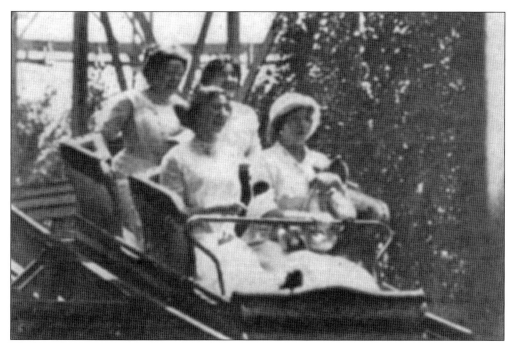

Thrill-seeking picnickers rode on the roller coaster—just one small part of the day's activities. Imagine the fun that was had by all! (Courtesy Ron Steinberg and Lucent Technologies Inc./Bell Labs.)

To truly imagine the fun that was had by all, step outside your 21st Century frame of reference for a moment. Forget the over-stimulating entertainment of computers, video games, movies, and Disneyworld-style thrill rides. Try to imagine the simple yet incredible fun in trying to catch a greased pig. This recipe for entertainment, laughter, and fun was simple: one bucket of grease and one frightened, squealing pig. (Courtesy Ron Steinberg and Lucent Technologies Inc./Bell Labs.)

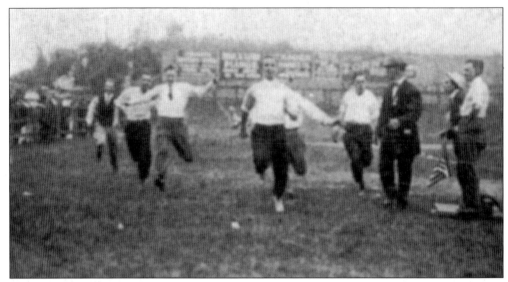

There were numerous sporting events, including a running race of every sort. "Men will run, women will run, children will run, and perspiration will run," one employee wrote. There were races for the boys (16 years and under), single men, married men, and the foremen of the factory. There was even a race for the more portly of the men—the "fat man's waddle." (Courtesy Ron Steinberg and Lucent Technologies Inc./Bell Labs.)

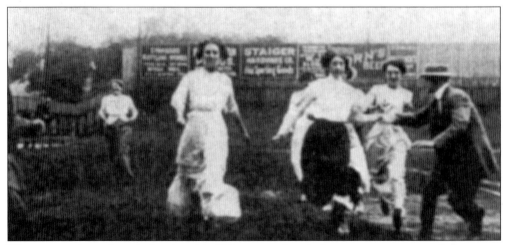

There were women's races for the girls (16 years and under), young women, married women, mixed couples' relay, and even a three-legged race. Imagine running in those long dresses! Skinned knees were common but were not a problem: A nurse's tent was set up and equipped to handle any minor cuts and bruises resulting from the day's activities. (Courtesy Ron Steinberg and Lucent Technologies Inc./Bell Labs.)

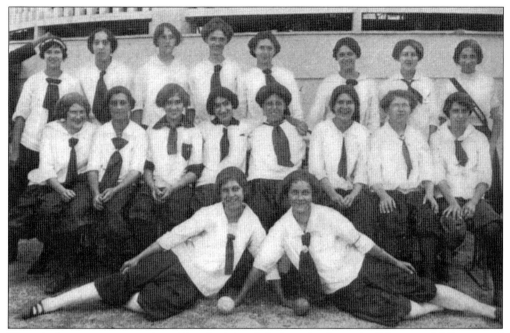

Though the amusement park and beach claimed their enthusiasts, the "bloomer girls" attracted the largest crowd. They played "indoor" ball (or "playground" ball), which was one of the more popular sports of the day. (Courtesy Ron Steinberg and Lucent Technologies Inc./Bell Labs.)

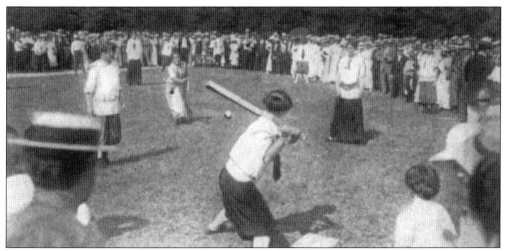

Indoor ball was a cramped game, its rules designed for playing inside gymnasiums. A huge and very soft ball and a stick for a bat were used. No gloves were worn. The pitcher was less than two dozen feet from home plate, and the distance between the bases was not much farther. Shown is an outdoor game of indoor ball. (Courtesy Ron Steinberg and Lucent Technologies Inc./Bell Labs.)

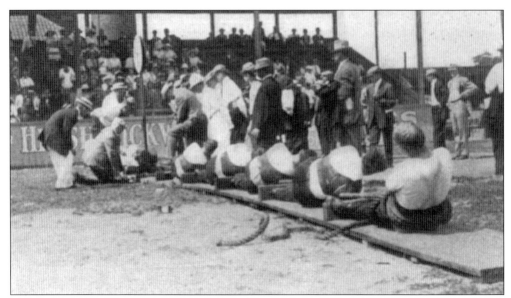

Many other team events were held, including the tug-of-war competition among the men. Part of the day's fun, these matches were grueling battles between rival departments. Bragging rights would go to the department whose team was victorious. After several minutes of strenuous, exhausting pulls, the margin of victory frequently was one inch or less. One Hawthorne Works employee described the excitement of the tug-of-wars: "Two evenly matched teams will face each other, and if they don't keep you right up on your toes, it is a sure sign you are growing old." (Courtesy Ron Steinberg and Lucent Technologies Inc./Bell Labs.)

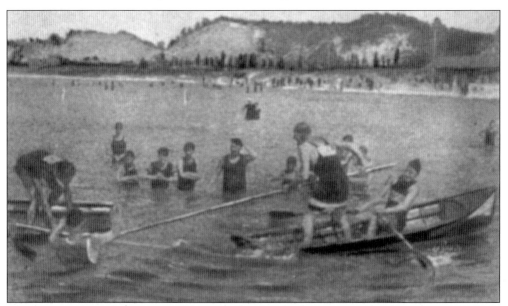

There was no better way to cool down on a warm July day—especially after competing in the various athletic contests—than to participate in the water events. Contestants in the tilting matches tried to bump each other out of their boats by means of long poles with padded ends. "If you aren't fond of water, don't rock the boat," mused one Hawthorne Works employee. (Courtesy Ron Steinberg and Lucent Technologies Inc./Bell Labs.)

Many people described the greased pole as more work than play. For some, it was perpetual motion—three feet forward movement followed by three feet backward. The reward, win or lose, was the ensuing splash into Lake Michigan. (Courtesy Ron Steinberg and Lucent Technologies Inc./Bell Labs.)

The "bathing" beaches of the Lake Michigan shoreline offered the children a refreshing and exciting playtime. (Courtesy Ron Steinberg and Lucent Technologies Inc./Bell Labs.)

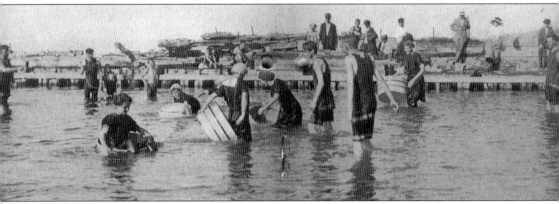

Tub races were held for the men and the women. "The name *tub* race," wrote one employee, referred to "the vehicle used, not to the shape required for entry." (Courtesy Ron Steinberg and Lucent Technologies Inc./Bell Labs.)

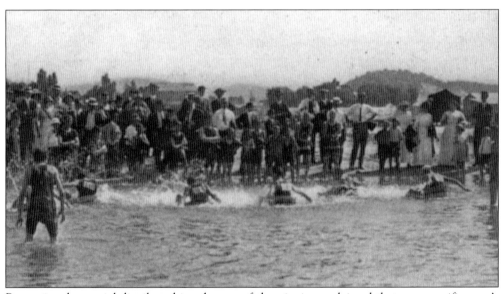

Promotional material distributed in advance of the picnic proclaimed that one specific men's tub race was reason alone worth going to Michigan City. It pitted one employee against another: "N. M. Argo (220 pounds, 6 foot 3 inches) in a tub race with Jeff Huntington (100 pounds, 4 foot plus)." (Courtesy Ron Steinberg and Lucent Technologies Inc./Bell Labs.)

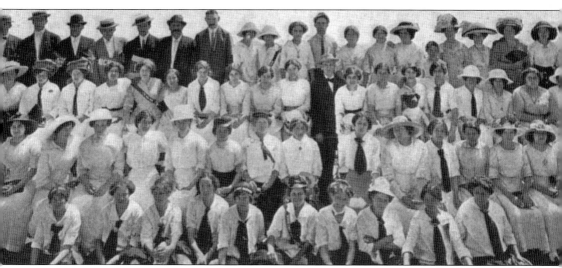

Attendance at the picnics began to really take off starting with the 1913 picnic. After attendance of approximately 3,500 for the first two years, the attendance in 1913 jumped to over 6,000. One reason for this was that contests were held for attendance. Supervisors would encourage their staff to attend, with hopes of winning the best attendance crown. Department 3300 (pictured above) won the distinction at the 1914 picnic by representing the largest percentage of employees in any one department. (Courtesy Ron Steinberg and Lucent Technologies Inc./Bell Labs.)

Another reason for the attendance surge from 3,500 to 6,000 was a change in how the employees promoted the excursion and picnic. During the early years, it was more an *immediate* family affair—husband, wife, and children. In 1913, the promotions began to spread to include the *extended* family. "Bring along her mother and her sister and her sister's youngsters. Make a family party of it. They will all enjoy it. There will be fun enough for everybody all day long and some left over to take in to the neighbors when you get back." With attendance swelling, provisions had to be made for additional capacity, which meant additional ships. To help provide additional capacity for the swelling crowd, an additional excursion ship was chartered for the 1914 picnic—the *Eastland*.

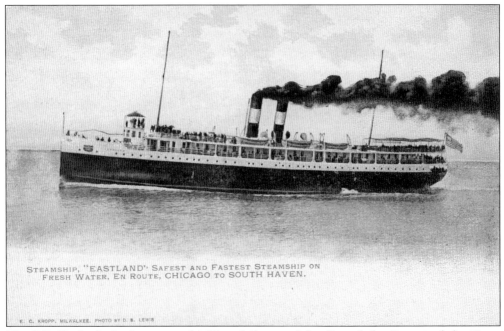

STEAMSHIP, "EASTLAND" SAFEST AND FASTEST STEAMSHIP ON
FRESH WATER, EN ROUTE, CHICAGO TO SOUTH HAVEN.

E. C. KROPP, MILWAUKEE. PHOTO BY D. S. LEWIS

The S.S. *Eastland*, also known as the "Speed Queen of the Great Lakes," serviced the Great Lakes beginning in 1903. This photo shows the *Eastland* early in her career when her regular daily commute ran between Chicago and South Haven, Michigan. (Courtesy *Eastland* Disaster Historical Society.)

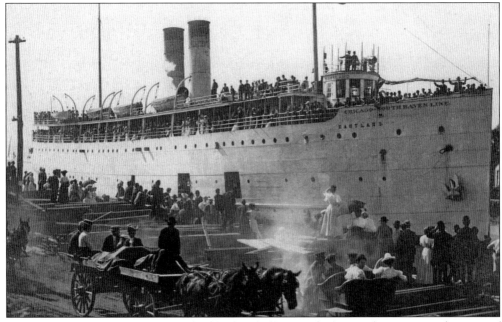

A little later in her career, the *Eastland* had its hull painted white and was operated as part of the Chicago-South Haven Line, a partnership between its owners, the Michigan Transportation Company, and the Dunkley-Williams Steamship Company. (Courtesy *Eastland* Disaster Historical Society.)

40

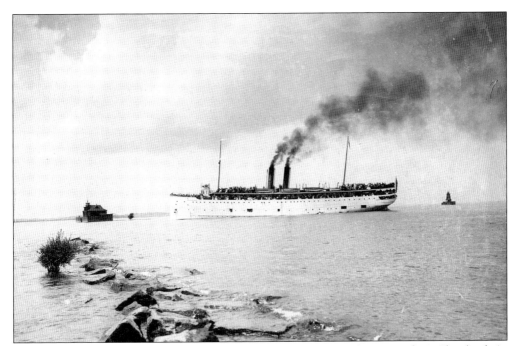

Before the 1907 excursion season, the *Eastland* was sold to a group of investors from Cleveland. As a result, the *Eastland* serviced Lake Erie from 1907 through 1913, with its regular commute being between Cleveland and Cedar Point, Ohio. (Courtesy *Eastland* Disaster Historical Society.)

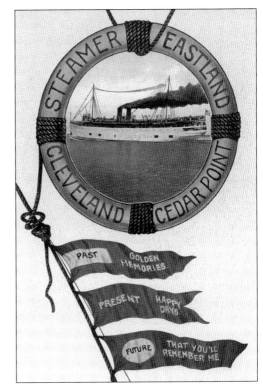

Passengers on the *Eastland* for its Cleveland to Cedar Point route could buy this postcard or other variations of it. At the time they were purchased and used, these postcards meant little to anyone. Years later, however, the third pennant made these postcards seem strangely prophetic. (Courtesy *Eastland* Disaster Historical Society.)

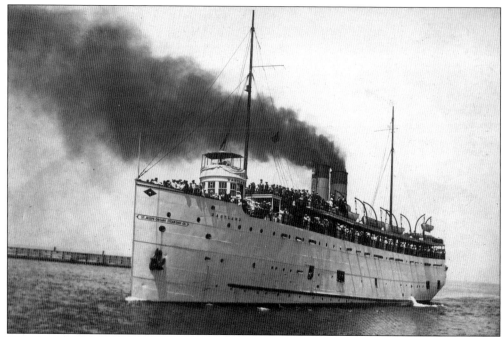

The *Eastland* returned to service once again on Lake Michigan in 1914 after being purchased by the St. Joseph-Chicago Steamship Company. Its daily route, naturally, ran between Chicago and St. Joseph, Michigan. (Courtesy *Eastland* Disaster Historical Society.)

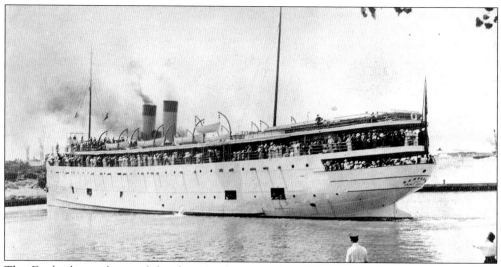

The *Eastland* was chartered for the Hawthorne Work's picnic for the first time in 1914. It departed second, after the *Theodore Roosevelt*, and took hundreds on the excursion across Lake Michigan. The passengers were discharged, and the *Eastland* returned to Chicago for its regularly scheduled 2:00 p.m. commute to St. Joseph, Michigan. But because of some difficulty experienced in unloading in Michigan City, the *Eastland* was delayed and was late in returning to Chicago. This seemingly trivial delay in 1914 would turn fateful for the following year—the 1915 Hawthorne Work's employee excursion and picnic. (Property of AT&T Archives. Reprinted with permission of AT&T.)

The 1915 employee picnic was heavily promoted. The front cover of the monthly employee newsletter made it obvious that <u>everyone</u> was going to the picnic, even if they had to get there by plane! One article made this point: "Everybody is preparing for the big picnic at Michigan City on the 24th and it is next to impossible to interest them in anything else." (Courtesy Ron Steinberg and Lucent Technologies Inc./Bell Labs.)

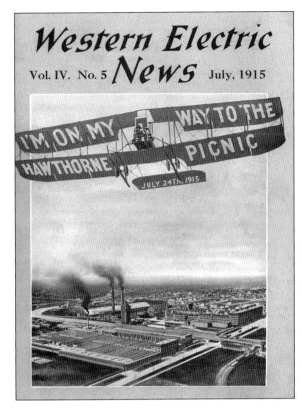

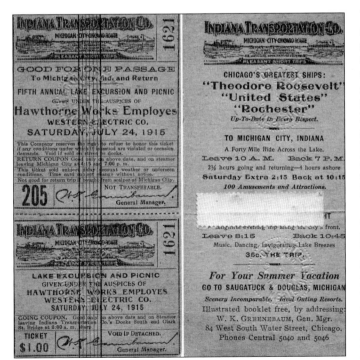

The ticket price for an adult was $1 each, or $.75 each if purchased in advance. (Note, these ticket prices were not as nominal as it may seem to readers of this book. Nicholas Suerth, a supervisor at the Hawthorne Works, took home $17 a *week* as salary while working full-time.) More tickets were sold in 1915 than ever before—over 7,000 had been purchased for the event. "Summer wouldn't be summer without the picnic" was the mainstream thought, and ticket sales reflected it. (Donated by the Timothy family; courtesy *Eastland* Disaster Historical Society.)

43

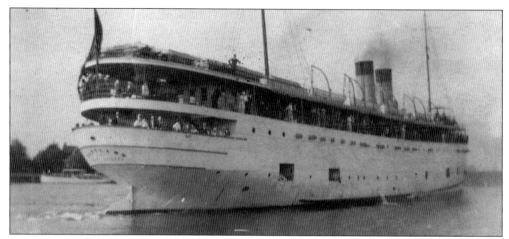

Because the *Eastland* ran late in 1914, and to avoid a repeat of this undesirable situation, the *Eastland's* owners required her to be the first ship to depart in 1915. The picnickers, many of whom wanted to be on the first ship to depart, awoke early. "We got up at 4:30 in the morning of July 24th," wrote Mrs. C. C. (Mamie) Kelly, "and left our house at 5:40 to get the 6:00 a.m. train so as to get to the boat and get good seats." (Courtesy *Eastland* Disaster Historical Society.)

When the *Eastland* ran her normal daily commutes between St. Joseph and Chicago, finding a good seat was generally not a problem as can be seen in the photo. It was a different story the morning of the 1915 picnic. "We got down to the dock rather early," said George Goyette. "I remember looking at a big clock on a warehouse across the river [the Reid, Murdoch & Company building] as I came out on deck, and noticing that it was just ten past seven. Even then, twenty minutes before sailing time, it was hard to get a good place [to sit]." George continued: "I went outside to try and find a seat. The dock side and front of the deck were, I knew, so crowded as to be out of the question, so I went around on the river side. It was almost as full here. There were two solid lines of occupied chairs, one against the rail and one against the side, down the whole length of the boat. The space between these [two rows] was filled with people standing and walking around." (Courtesy *Eastland* Disaster Historical Society.)

Boarding of the *Eastland* ran at a rate of about 50 passengers per minute. Though there was no passenger manifest, passengers—from Aanstad to Zobac—boarded before the *Eastland's* capacity of 2,500 was attained. Musicians played ragtime while passengers danced. Moments later, and for hundreds of passengers, the music stopped playing—forever.

Six

THE *EASTLAND* DISASTER

"No man is a hero under water."—J. V. Brown

Before the *Eastland* cast off her lines from the wharf area west of the Clark Street Bridge, it rolled into the Chicago River with over 2,500 passengers, including crew members, on board. In just minutes, nearly 850 people lost their lives, including 22 entire families. George Dubeau, a Western Electric employee who observed the tragedy from his position on the S.S. *Theodore Roosevelt*, recalled: "It was a terrible sight—men and women and children being plunged into the water and all screaming. In a minute the water was full of people with only their heads above water and all calling to be saved—that is, those who did not sink at once." The odds of hitting an iceberg at sea were one-in-a-million. As it turned out, the odds of an excursion ship rolling over—on a summer day, in the heart of the world's greatest city, while still moored to its wharf on a shallow river—were greater.

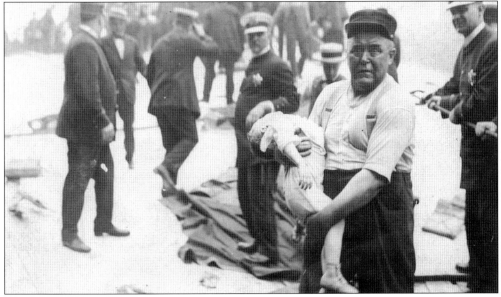

"We have had picnics before, and not one of them was to be sneezed at, either, but <u>they will all be forgotten after this one</u>." The fateful words from the Western Electric *News*, July 1915, turned out to be an unfortunate prophecy. (Donated by Lynn Steiner; courtesy *Eastland Disaster Historical Society*.)

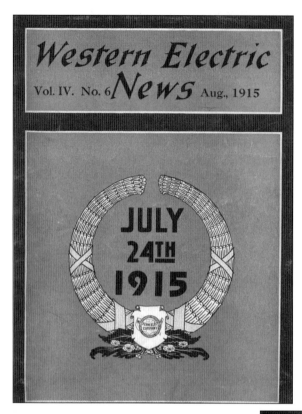

Whereas the July 1915 cover of the Western Electric *News* touted the picnic, a month later the cover of the August edition—and its entire contents—was a memorial to the victims of the tragedy. The leaves forming the wreath are bay leaves, the sign of mourning. The flowers beneath the wreath are English hawthorn, the symbol of hope. (Courtesy Ron Steinberg and Lucent Technologies Inc./Bell Labs.)

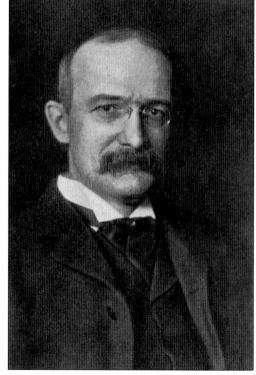

Western Electric President Harry B. Thayer, from his office in New York, addressed a memo to the employees of Western Electric. It began: "We are the victims of a disaster so awful that the world has stood aghast at its horrors, even in this year of horrors. Of our fellow workers, 500 have gone down to sudden death. Many are mourning for members of their families, and many for friends and acquaintances. Gloom hangs heavy." Thayer's comments regarding the *Eastland* Disaster of July 24, 1915 quite easily could be substituted as a description of the tragic events of the September 11, 2001 terrorist attacks. (Courtesy Ron Steinberg and Lucent Technologies Inc./Bell Labs.)

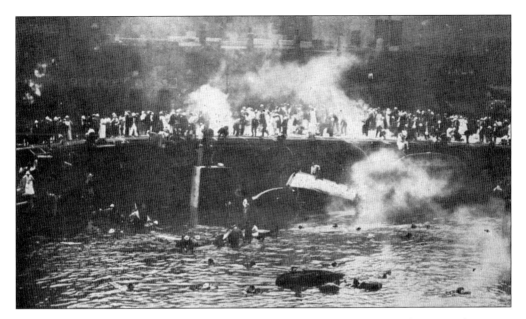

The sights and sounds of the tragedy, even with significant photographic record, remain incomprehensible. Western Electric nurse Helen Repa, who arrived just a few moments after the *Eastland* had rolled into the river, described the utter chaos: "I shall never be able to forget what I saw. People were struggling in the water, clustered so thickly that they literally covered the surface of the river. A few were swimming; the rest were floundering about, some clinging to a little raft that had floated free, others clutching at anything they could reach—at bits of wood, at each other, grabbing each other, pulling each other down, and screaming! The screaming was the most horrible of all." (Photos courtesy *Eastland* Disaster Historical Society.)

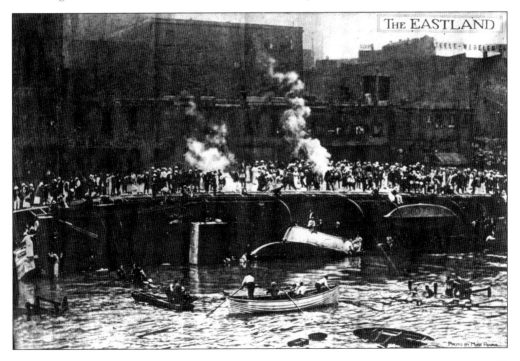

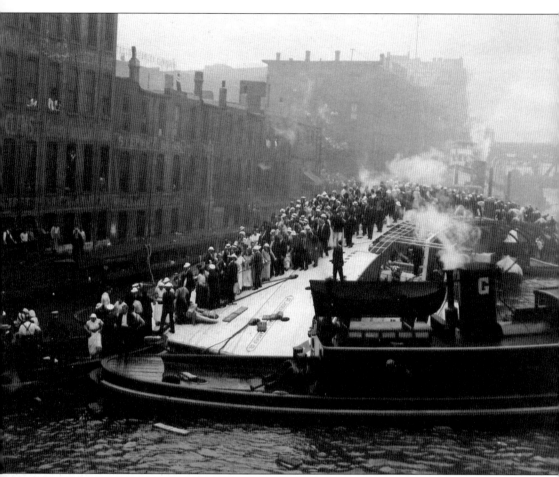

Harlan Babcock, a reporter for the *Chicago Herald*, also observed the pandemonium and noted: "Never to my dying day shall I forget the supreme horror of that moment. Men, women, and children, who a moment before had been laughing and shouting messages to one another on board the *Eastland* and to friends on shore, were hurled by the hundreds into the Chicago River. As the top-heavy vessel careened on its side, screams and wails, sobs and pitiful prayers came from those on the upper deck. They were hurled off like so many ants being brushed from a table." (Courtesy Chicago Historical Society, *Chicago Daily News* negatives collection, DN-0064949.)

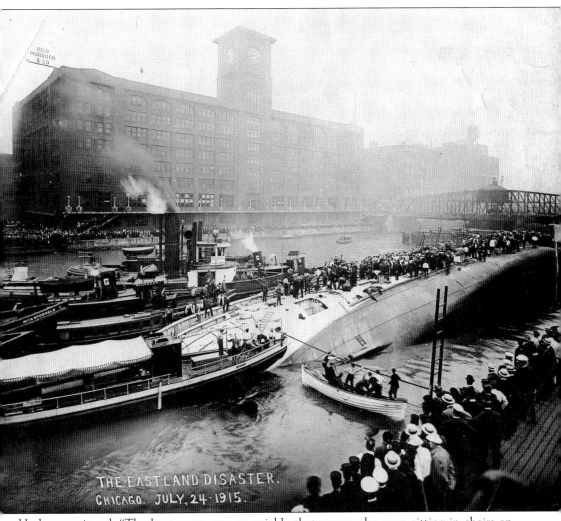

THE EASTLAND DISASTER.
CHICAGO. JULY. 24-1915.

Harlan continued: "The boat went over so quickly that scores who were sitting in chairs on deck did not have time to rise but were shot into the river. In an instant, the surface of the river was black with struggling, crying, frightened, drowning humanity. Infants floated about like corks. Cries of 'Help!' from those in the water filled the air. Many sank instantly. Others turned white, lifting imploring faces toward the panic-stricken crowd on the nearby Clark Street bridge and piers. But before help could reach them, they too sank. I was chilled by the harvest of death." The building in the background with its distinctive clock tower was that of wholesale grocer Reid, Murdoch & Company. The Clark Street Bridge is in the background on the right. The stern of the *Eastland* rests over the LaSalle Street Tunnel—in 1915, a bridge over the Chicago River at LaSalle Street did not exist as it does today. (Courtesy *Eastland* Disaster Historical Society.)

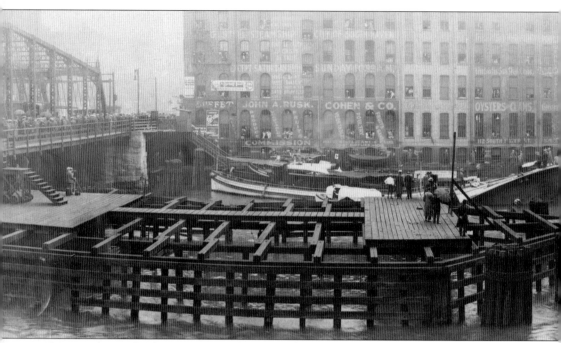

Because the *Eastland* capsized so suddenly, no life boats or life rafts were launched, nor were any life jackets handed out. This panoramic photo was taken from the walkway of the Reid, Murdoch & Company building showing the view from the north bank of the Chicago River. In the distance to the far right is the steamer *Petoskey*. The *Petoskey* was one of the five excursion ships chartered for the morning excursion. It had already been boarding passengers when the *Eastland* rolled over, affording its passengers and crew a perfect, unobstructed view of the

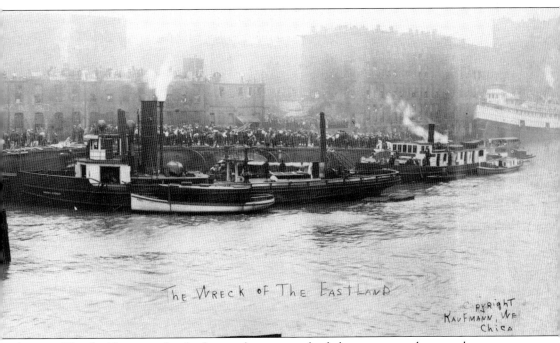

The Wreck of The Eastland

Copyright
Kaufmann, We
Chica

disaster. The buildings in the background are several of the game, produce, and grocery commission stores. The fronts of these buildings faced South Water Street (West Wacker Drive, today), the location of the South Water Street market. The large boat to the right of the pilothouse of the overturned *Eastland* is the Chicago Fire Department fire boat, the *Graeme Stewart*. It arrived on the scene within minutes of the capsizing of the *Eastland*. (Courtesy Library of Congress, Prints and Photographs Division LC-USZ62-126620.)

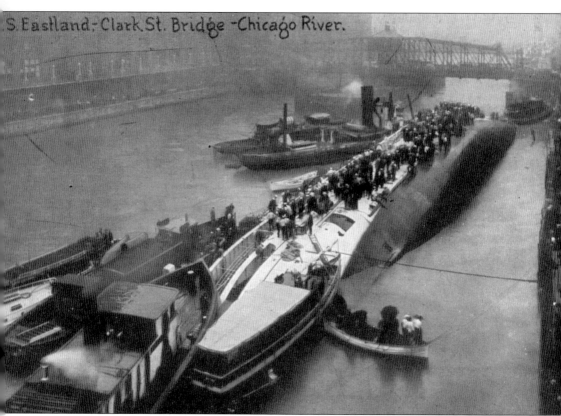

The overturned hull of the *Eastland* was teeming with passengers who had scrambled to a position of temporary safety. "It looked like a prehistoric creature, a dead dinosaur covered with parasites," wrote author Jay Bonansinga in his 2004 book, *The Sinking of the Eastland: America's Forgotten Tragedy*. And while hundreds managed to make it to the safety of the hull, hundreds of others were not as fortunate. Survivor L. D. Brown stated later: "All at once the boat was seen to list and then roll over carrying with it the merrymakers to a terrible death. The passengers were caught like rats in a trap. Hundreds hemmed in between the decks and in the hold never had the least chance of escape." (Courtesy *Eastland* Disaster Historical Society.)

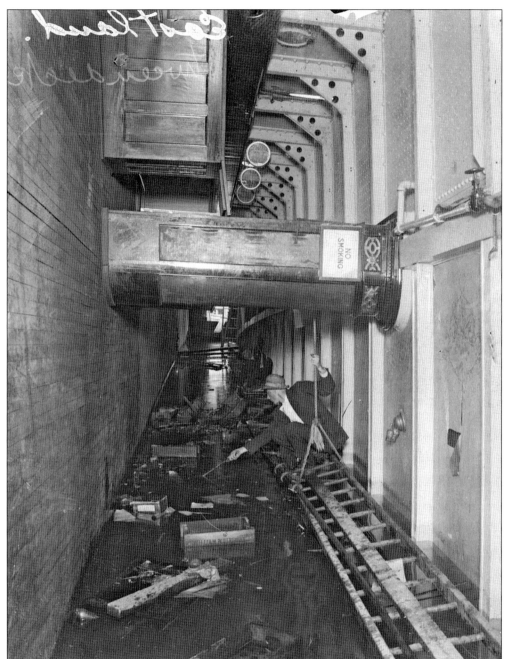

In a matter of seconds, the interior of the Eastland changed dramatically. "Floors became walls, portholes became skylights," wrote Bonansinga, "the gigantic influx of water turned the mahogany-trimmed rooms into sealed chambers worthy of Harry Houdini's worst nightmares." Note the portholes (skylights) hanging open at the top. A small amount of debris can be seen still floating on the water between decks. Turning the book counter-clockwise (90 degrees to the left) provides a glimpse into how the interior of the ship would have looked to the passengers before it rolled over on its side. The view is looking from the bow toward the stern. (Courtesy Chicago Historical Society, *Chicago Daily News* negatives collection, DN-0064951.)

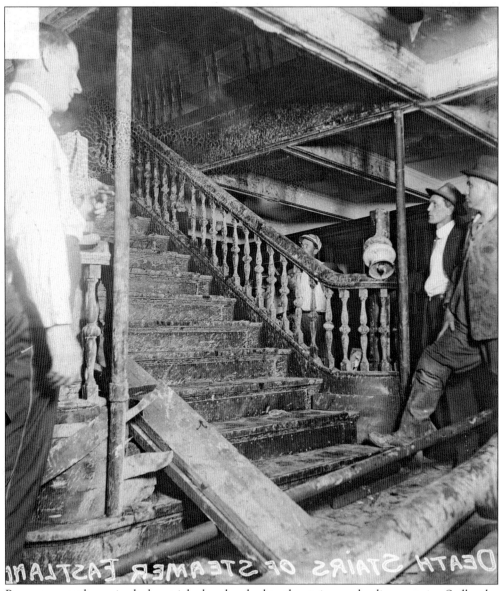

DEATH STAIRS OF STEAMER EASTLAND

Passengers on the main deck panicked and rushed to the staircases leading upstairs. Sadly, the staircases proved to be the worst single death trap for those passengers within the interior decks of the ship. J. V. Brown was one of the very few to escape of those who were caught on the river side of the lowest deck. He described his escape: "Suddenly I saw water begin to come in through the portholes. My idea was to get up the stairs to the deck above, which was more open. I swam over and started to go up—or rather along—them, for the boat was on her side by this time. But suddenly one of the people in the water grabbed my legs, another got hold of one arm, and a third got me by the hair. Let me tell you, no man is a hero under water. I fought. I finally got loose—still under water—and managed to get to the top of the stairs. It was pitch black." This view is of the interior of the Eastland after it was righted. Turning the book counterclockwise (90 degrees to the left) reveals how it would have appeared to J. V. Brown as he ascended (swam along) the stairs. (Courtesy Chicago Historical Society, Chicago Daily News negatives collection, DN-0065030.)

54

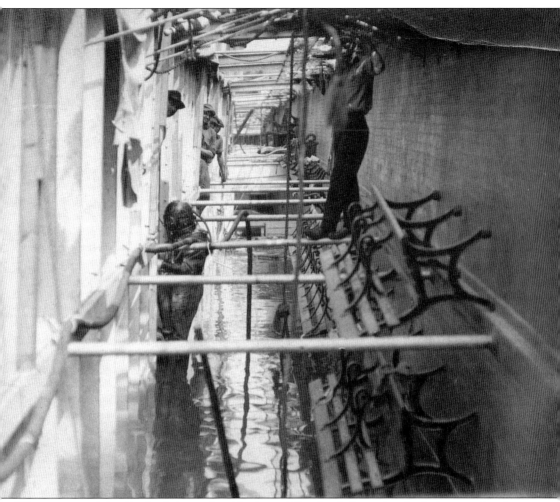

"The interior of the *Eastland* changed suddenly, as if by the dark magic of a funhouse mirror" wrote Bonansinga. The photo is of the promenade deck (the top deck of the three main decks), the starboard side of the Eastland looking from the stern toward its bow. This is the part of the ship that remained above water. Turning the book clockwise (90 degrees to the right) reveals how the deck would have looked to passengers before the Eastland rolled over on its side. Passengers sitting on the benches who were enjoying the open view were hurled backwards into the water. (Donated by Ken Glasener; courtesy Eastland Disaster Historical Society.)

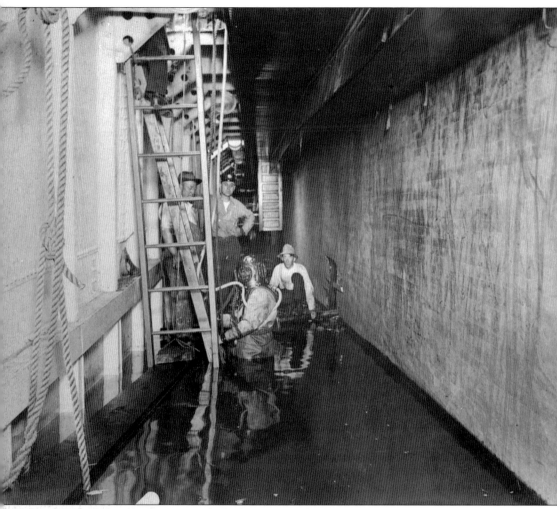

George Goyette, who was on deck when the *Eastland* rolled, described the experience of a ship turning over on its side: "What I saw was exactly what you see when you watch a lot of children rolling down the side of a hill. The entire crowd of men, women, and children came slipping and sliding and sprawling down with a mass of lunch boxes, milk bottles, chairs—rubbish of every sort—on top of them. They came down in a floundering, screaming mass, and, as the boat turned completely over on its side, crashed into the stairs, carrying them away." Though not present or visible in this photo, the slipping, sliding, and sprawling mass is self-evident in the vertical skid-marks on the hardwood floor. Turning the book clockwise (90 degrees to the right) reveals one final time how the deck would have looked to passengers before the ship rolled over. (Courtesy Chicago Historical Society, Jun Fujita collection, ICHi15794.)

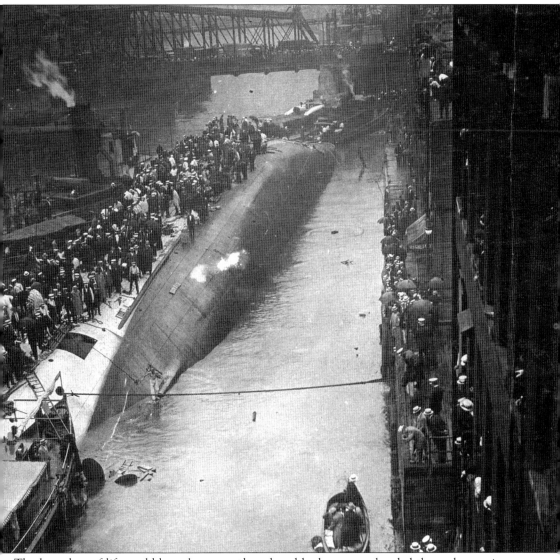

The huge loss of life could have been greatly reduced had someone heeded the early warning signs and signaled an alarm. "We noticed that the boat seemed to be tipping over a good deal, but we didn't think much about it until it went clear over," said survivor Lawrence Kramer. L. E. Friedhelm, who was working along the wharf, said: "I saw the crowds on the boat. They did not seem to suspect any danger. As the boat started to tilt the people laughed and joked. It was only at the last that they realized that they were doomed." Joe Lannon affirmed these observations with that of his own: "When the ship first started to turn over, everybody took it as a joke. Then when the boat listed over so far that the people began to slide across the floor, the panic began." Kramer, Friedhelm, and Lannon's perspectives were widely shared among many of the passengers and onlookers. But not only did most passengers not recognize the impending disaster, the master of the *Eastland*, Captain Harry Pedersen, failed to evacuate the ship. He sounded the alarm, but only after it was too late. Once the *Eastland* went over, it came to rest in the muddy bottom of the Chicago River in just 20 feet of water. Her bow was a mere 19 feet from the wharf. No iceberg, no torpedo—but plenty of human error. (Donated by the family of John Tamm; courtesy *Eastland* Disaster Historical Society.)

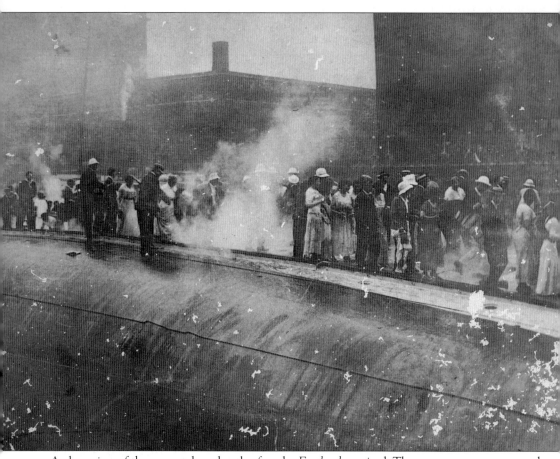

A close view of the scene taken shortly after the *Eastland* capsized. The scene seems very surreal, the passengers seem to be in a zombie-like state of shock. Most of these people probably did not yet comprehend the enormity of the disaster when this photo was taken. (Courtesy family of Grace Rabe Nilsen.)

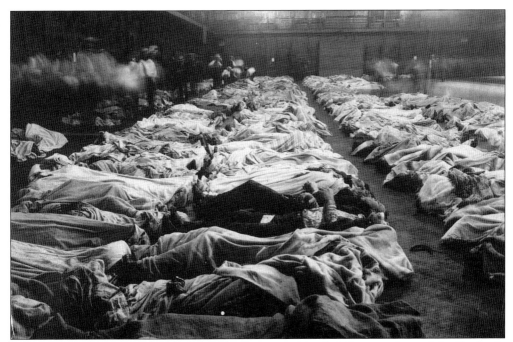

Nearly 850 passengers perished—Babcock's "harvest of death." Two members of the *Eastland's* crew also perished. Some passengers were killed instantly after suffering a blow to the head. Many drowned, and perhaps just as many or more were suffocated, crushed to death by the sliding people and falling debris that rained down upon them. (Courtesy Chicago Historical Society, Jun Fujita collection, ICHi30728.)

Peter Boyle, a young 23-year-old man who was born on Arranmore Island in County Donegal, Ireland, had only recently arrived in the United States. His parents remained in Ireland and depended upon his financial support. Peter died in the tragedy, yet he was neither a passenger nor member of the *Eastland's* crew. Rather, Peter was a lookout on the steamer *Petoskey*. A gallant lad, Peter sacrificed his own life by jumping off the *Petoskey* into the river while attempting to rescue a woman who had been thrown into the water by the capsizing *Eastland*. (Courtesy Nora Boyle, niece of Peter Boyle.)

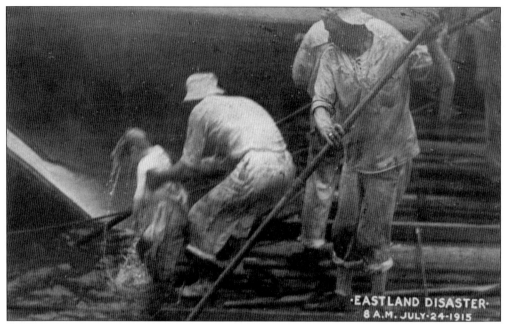

Of the passengers who perished, 228 were teenagers, and 58 were infants and young children. (Courtesy *Eastland* Disaster Historical Society.)

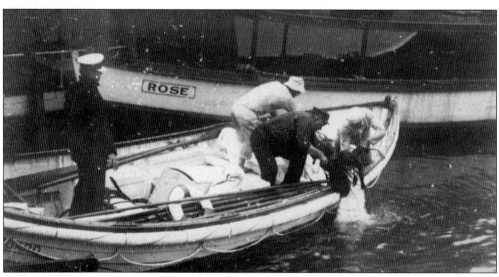

Seventy percent of the victims were under the age of 25. The average age of those who died was only 23. (Courtesy *Eastland* Disaster Historical Society.)

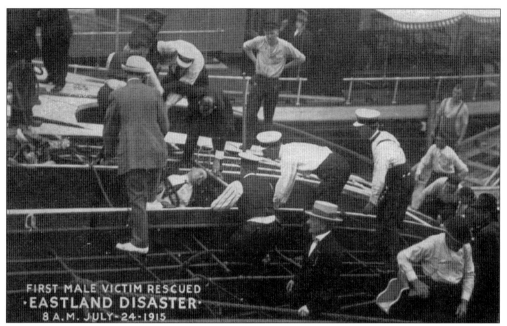

Of the 175 women who went home as widows, three were pregnant. (Courtesy *Eastland* Disaster Historical Society.)

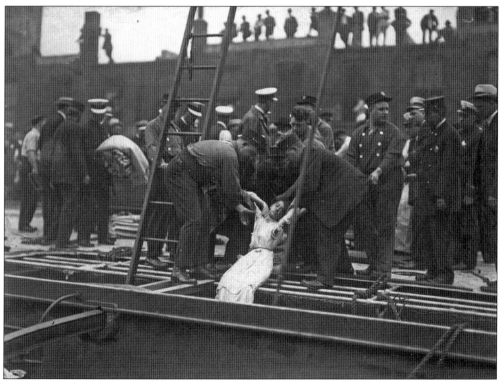

The tragedy sent 84 men home as widowers. (Courtesy *Eastland* Disaster Historical Society.)

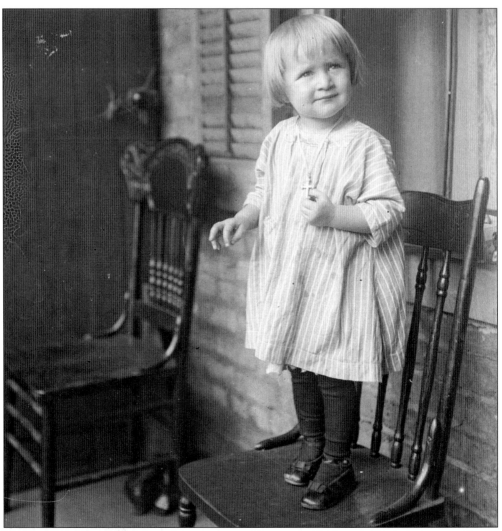

Nineteen families were left without parents. Two-year-old Eleanor Freilich (pictured) was immediately orphaned when both of her parents perished in the tragedy. She was raised by her grandparents. The cross she holds would be symbolic of her adult life—she became a nun, serving until her death at age 90. Young Violet Zobac (22 months) and her infant brother Harold (5 months) were at home with their grandmother while their parents, Edward (24) and Anna (22) Zobac, went to the picnic—they never returned home. The two young Zobacs were adopted by their Uncle Joseph and Aunt Josephine Zobac. Fred and Clara Ehrhardt, 31 and 32, respectively, both perished, orphaning their two young children, Raymond (10) and Ione (6). Whereas the Zobac youngsters were adopted and kept together by family, Raymond and Ione were eventually split up and did not stay in contact very often. The *Eastland* Disaster had caused their family to be split apart not just once, but twice. (Courtesy Chicago Historical Society, *Chicago Daily News* negatives collection, DN-0064919.)

While months of planning and preparation for the excursion and picnic led up to the *Eastland* Disaster, the tragedy itself was, for all intents and purposes, over in a matter of minutes. The rescue, recovery and relief efforts following the tragedy, however, went on for weeks and months—and years—and decades.

Seven
THE RESCUE, RECOVERY, AND RELIEF

"Tears falling from the sky."—Frank Blaha

Western Electric responded to the disaster in an admirable fashion, and did all it could to ease the pain, suffering, and hardship of the victims' families. Countless other organizations responded: the Chicago Fire Department, Chicago Police Department, United States Coast Guard, American Red Cross (local Chicago office as well as the national office), Cook County Coroner's Office, Chicago Telephone Company, Commonwealth Edison, Marshall Field & Company, Sherman and LaSalle Hotels, Steffey Brothers Wholesale Commission, Boy Scouts of America, Oak Park Charities, Bohemian Aid Society, Chicago Department of Health, the churches, the undertaking establishments, the hospitals, Reid, Murdoch & Company, and the list goes on and on. Of course, thousands of individuals responded in one or more ways, too. It is impossible to identify all who helped during the aftermath of the tragedy. The aftermath that was unlike any other was only briefly about rescue and survival—it was mostly concerned with recovery.

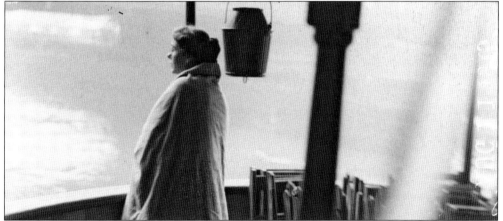

A young woman wrapped in a blanket stands on the deck of one of the nearby ships. This is one of the more poignant images from the tragedy, and represents the group that was impacted the most—young women. She appears to be staring out at the chaos in front of her—probably numb and in shock. The deck chairs are folded and stacked, chairs that earlier were open and filled with hundreds of jubilant merrymakers. Now alone, she may already be aware that she has lost a family member, or perhaps a friend or co-worker. Perhaps she is wondering what her life and future will now hold for her. The scene is hazy and foggy, as if it was all a bad dream. (Courtesy Chicago Historical Society, *Chicago Daily News* negatives collection, DN-0064947.)

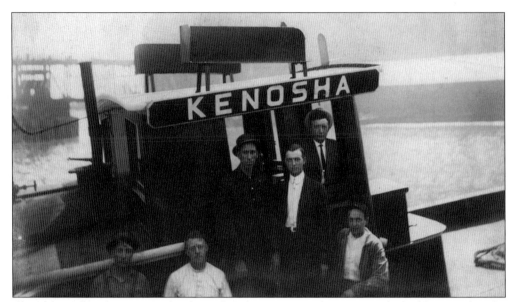

The rescue efforts began *immediately*. Earlier that morning, the tug *Kenosha* had been tied to the bow of the *Eastland* in preparation for towing her out onto Lake Michigan. Upon watching the *Eastland* roll into the Chicago River, Captain John O'Meara (standing directly below the letter 'H' in *Kenosha*) ordered his tug be secured to the wharf to form a bridge between the overturned hull of the *Eastland* and the safety of the wharf. (Courtesy family of Captain John H. O'Meara.)

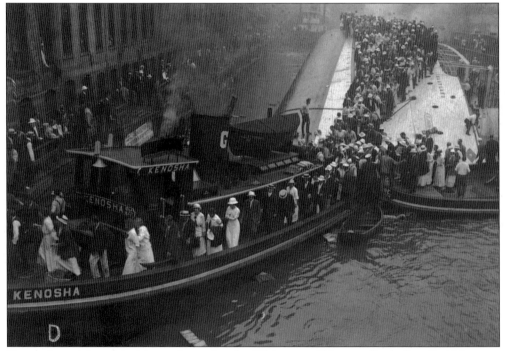

Due to the quick and decisive actions taken by O'Meara and his crew (including Carl Mattson, among others), the survival rate of the passengers was significantly increased. (Courtesy *Eastland* Disaster Historical Society.)

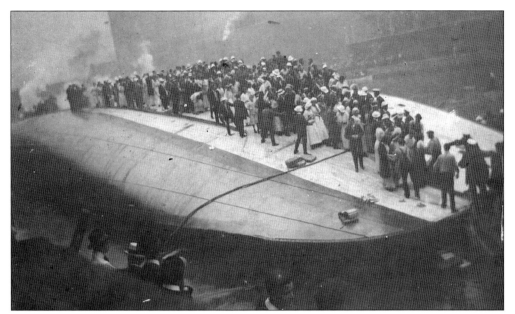

Hundreds of passengers, most who simply climbed over the starboard rail as the ship rolled over, walked over the *Eastland* and the *Kenosha* to safety—many without ever getting their feet wet. When the *Eastland* rolled over, its bow was still tied by its forward breast line to the spile. In this photo and the next, note the bent spile; the forward breast line is still evident. (Courtesy family of Theodore Jahnke.)

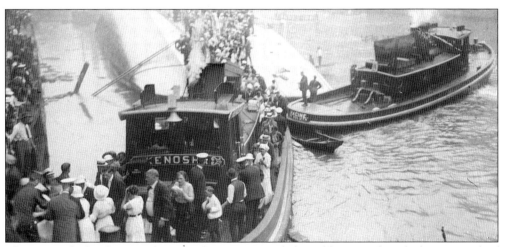

The crews of other boats and tugs in the area responded quickly, even though there was risk of a boiler explosion on the *Eastland*. "My father shouted for every man about the place to get aboard the (*Carrie*) *Ryerson*," said Ray LeBeau. "At that time I could see people beginning to jump off [the *Eastland*]. Seven of us piled aboard the tug and we tore up current as the *Eastland* went over. We were the first boat there except for the *Kenosha*, which was to tow the *Eastland* out. No, I couldn't tell you how many people we got out. The river was full of them and we were too busy to count 'em. I know there were 22 people on board the tug at one time. Henry Oderman, one of our shopmen, dived in and got one woman who was going down. It took us a long time to bring her to." (Courtesy Chicago Historical Society, *Chicago Daily News* negatives collection, DN-0064936.)

At that hour of the morning, only three people were at the Dunham Towing and Wrecking Company plant along the Chicago River: Superintendent F. D. Fredericks, Charlie Hart, and Johnny Benson. Though these three did not have a license and none was a regular engineer, they commandeered the tug *Rita McDonald*. "Come on boys, I can run that old engine!" Supt. Fredericks shouted to Hart and Benson. He continued: "On the way up [stream] we got in where the people were the thickest. Then we started picking 'em up. I don't know how many. Too busy to count. I'm tickled to death to think we were able to help as many as we did. Fifty? Oh, I don't know." (Courtesy *Eastland* Disaster Historical Society.)

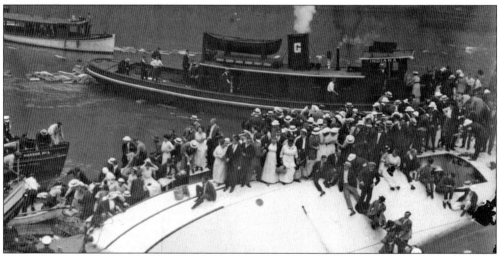

Captain Joseph Lamoreaux and his crew of the tug *Indiana* arrived at the scene and assisted in the rescue and recovery efforts minutes after the *Eastland* capsized. As a result of his horrifying experience in the rescue and recovery efforts, Captain Lamoreaux had nightmares about the tragedy for several months after the ordeal, and chose not to discuss it with family and friends. (Courtesy Chicago Historical Society, *Chicago Daily News* negatives collection, DN-0064949.)

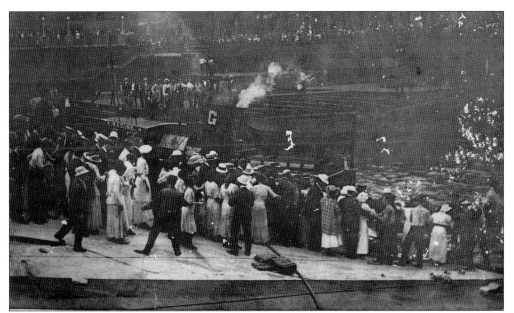

Survival for many was largely a factor of something as basic as the location—where they stood or sat—on the ship. "We were just at the right place at the right time," said survivor Clara Reisner. Ken Rabe, who survived along with his parents and older sister Grace, admitted: "We happened to be on the right side and so help me, I have no idea why we ever got there. But that was the decision [of our parents]—it's sort of a miracle." (Courtesy family of Grace Rabe Nilsen.)

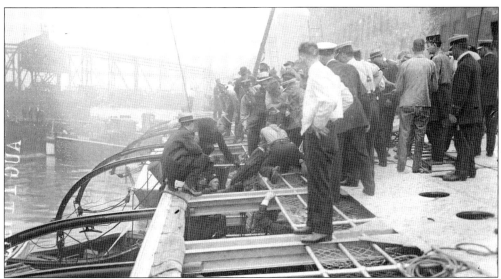

Generally speaking, those who were on one of the upper decks or the wharf (starboard) side of the ship had the highest chances for survival, while those who were below deck or on the river (port) side had the slightest chance for survival. "The people who were down below didn't have a chance to get out," recalled survivor Charles Agnos, "everybody was screaming, pushing, and running over everything." Frank Blaha added: "The people on that side—the side toward the center of the river—didn't have a chance. They just rolled right under." (Courtesy Chicago Historical Society, *Chicago Daily News* negatives collection, DN-0064945.)

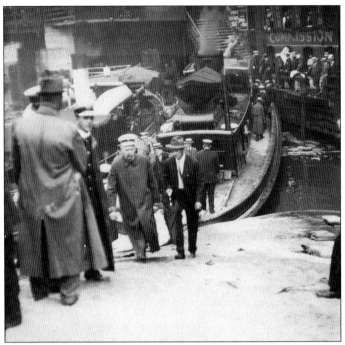

If you were one of those fortunate enough to find your way to a position on the side of the overturned *Eastland*, this was your view as you walked off the hull onto the *Kenosha*. Initially, this pathway to safety was somewhat hazardous. The water from the river and the rain, combined with the sharp downward slope of the slick steel hull, made the surface slippery. Walking in heavy, wet clothes with Sunday-best shoes, boots, and heels (and in some cases, stocking-covered or bare feet) made the already hazardous journey even more perilous. Moments later, crews from several of the assisting tugs spread ashes from their fireboxes onto the hull to provide better traction. (Donated by Ken Glasener; courtesy *Eastland* Disaster Historical Society.)

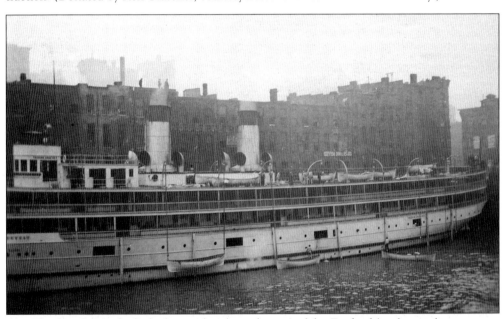

The *Theodore Roosevelt*, docked immediately to the east of the *Eastland* (at the southeast corner of the Clark Street Bridge) was already boarding passengers for the picnic. It was scheduled to depart at 8:00 a.m., shortly after the *Eastland*. After the *Eastland* went over, pandemonium broke out on the *Roosevelt* as women and men screamed and fought to get off the ship and back to safety on shore. Moments later, dozens of victims' bodies were brought aboard the ship, which served as a temporary morgue. (Courtesy *Eastland* Disaster Historical Society.)

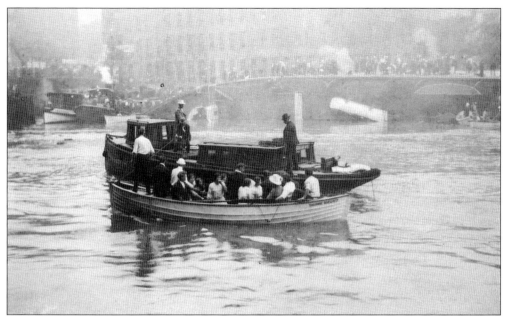

Several of the crew and passengers on the *Theodore Roosevelt* joined in the rescue efforts and threw dozens of life preservers into the river. As soon as Jack James Billow, a 15-year-old deck hand on the *Roosevelt*, saw the *Eastland* roll into the river, he and two other deck hands climbed into one of the *Roosevelt's* life boats and rowed over to the *Eastland* where people were everywhere in the water. They helped several people into their boat and got them safely to shore before assisting others. (Courtesy *Eastland* Disaster Historical Society.)

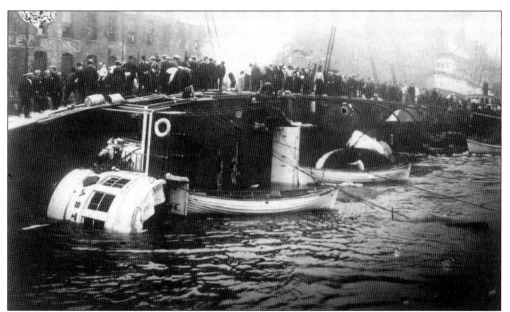

Weeks before the tragedy, several modifications had been made to the *Eastland*, including the addition of several life boats and life rafts (added as a result of the *Titanic* disaster). But because the *Eastland* capsized so quickly, no life boats or life rafts were launched. Instead, the life boats hung from their davits or broke free. (Courtesy *Eastland* Disaster Historical Society.)

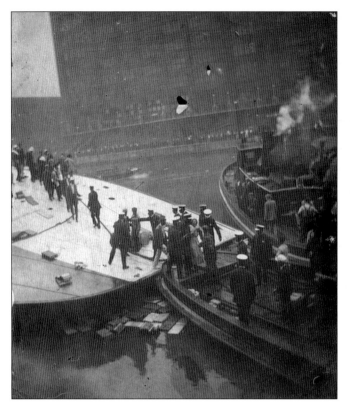

The *Eastland's* life jackets remained in their storage lockers or floated free on the river's surface—none really were used for the life-saving purpose for which they were intended. Some of the life jackets visible in these photos may have come from the *Theodore Roosevelt* and other nearby boats, as passengers and crew threw them into the river in an attempt to save those struggling for their lives. (Courtesy family of Theodore Jahnke.)

Ironically, the *life* rafts on the *Eastland* had very little to do with saving lives. They instead became a key transport vehicle used in the recovery of victims. (Donated by Ken Glasener; courtesy *Eastland* Disaster Historical Society.)

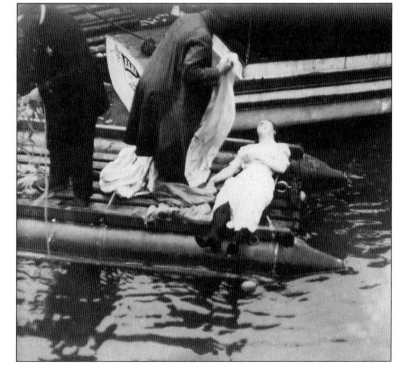

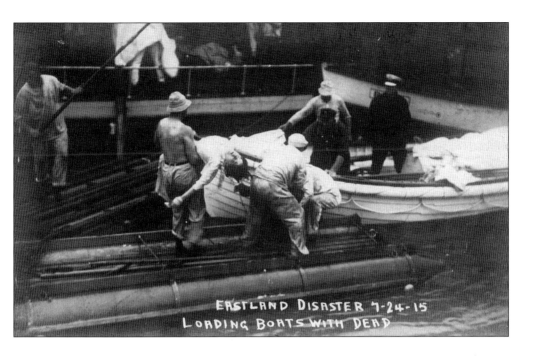

Postcards depicting scenes from the tragedy were printed, sold and postally used. Several of the postcards later had the faces whited out. Today, postcards of the *Eastland* Disaster are quite common. (Photos courtesy *Eastland* Disaster Historical Society.)

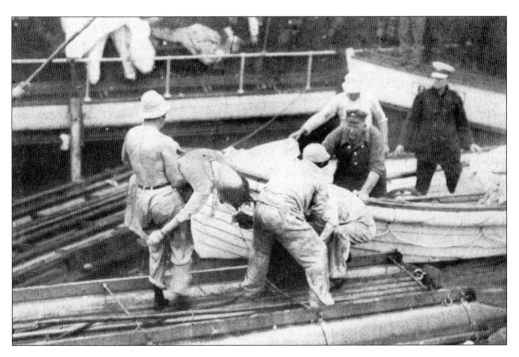

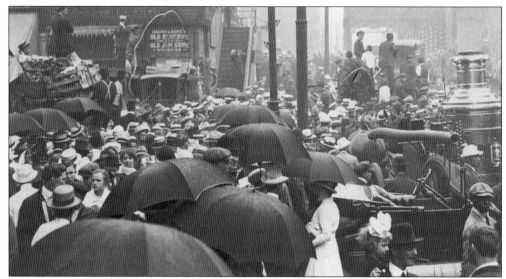

News of the disaster spread quickly, and within half an hour of the catastrophe the streets of the Loop (Chicago's downtown business district) were jammed with enormous crowds, including this one on South Water Street. While most of the crowd assumed the role of mere onlookers or curiosity seekers, hundreds assisted as best they could. Some people, many who had no connection to the picnic, even put their own well-being and lives at risk. Abraham Blumenthal, a young newspaper boy selling papers downtown, jumped into the river and helped rescue others. William Corbett was making laundry pickups for Munger Laundry when he stopped his truck, hopped out and began to assist. Morris Gault was downtown working at Hart, Shaffner & Marx when he left his work at the factory to help save people from drowning. "There were a million heroes that day. I don't suppose anybody ever knew their names," said Anna Meinert. A Chicago Fire Department horse-drawn truck can be seen working its way through the crowded street. (Courtesy Chicago Historical Society, Jun Fujita collection, ICHi02039.)

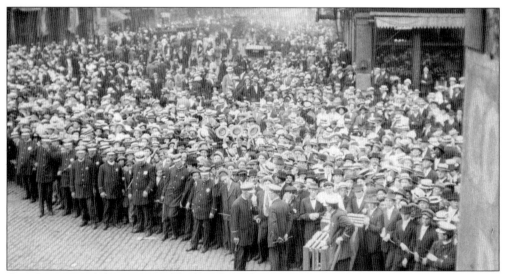

Crowds congested the streets and bridges throughout downtown Chicago, impeding the arrival of Chicago police and fire personnel. Dozens of Chicago police were deployed to maintain control of the crowds. (Donated by Ken Glasener; courtesy *Eastland* Disaster Historical Society.)

To the west of the disaster scene, the crowds gathered along the Wells Street Bridge. Elevated trains passed overhead, while streetcars stopped underneath. Several people reported later that they were riding an Elevated or streetcar moments before the *Eastland* rolled over, having a perfect view of the death and doom that occurred. The identifiable light-colored "skimmers," a popular men's hat of the era, are visible. (Donated by the family of Grey Warrner; courtesy *Eastland* Disaster Historical Society.)

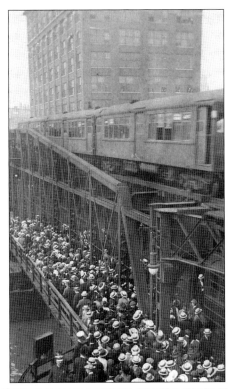

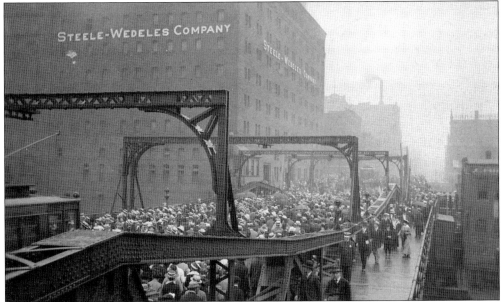

One block to the east of the disaster scene, crowds gathered along the Dearborn Street Bridge. The tender of this bridge, Laurence Frank Northrup, was standing by, ready to open the bridge for the *Eastland*. When he saw the ship topple over, he jumped into a nearby life boat and hurried to the scene. He helped haul people into the life boat, one and two at a time. Twenty-three people—men, women, and children—owed their lives to Northrup's presence of mind and quick action. (Courtesy *Eastland* Disaster Historical Society.)

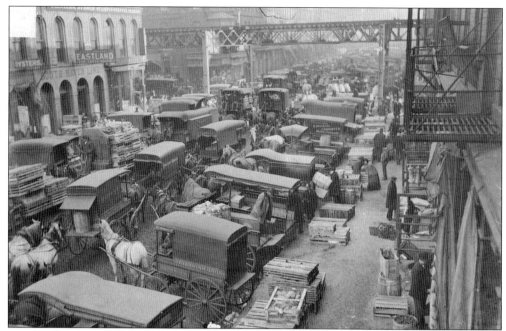

One block away from the wharf where the *Eastland* was moored, South Water Street ran parallel to the Chicago River. Many game, poultry, and produce wholesale commission stores operated in this downtown area, with their store fronts facing South Water Street. The rear of these stores formed the row of buildings directly adjacent to the wharf. (Courtesy Chicago Historical Society, *Chicago Daily News* negatives collection, DN-0000891.)

Turkeys (feathered or not) and pigs were among the products offered by the South Water Street merchants. The market was in full operation Saturday, even at such an early hour in the morning. "Minutes after the boat capsized, the river was full of people," said one member of Grace Lutheran Church. "Poultry houses located on the banks of the river threw empty chicken crates out on the water to which people could cling till they were rescued." This action had mixed results. While helping some to survive, it unfortunately knocked others unconscious or drove them below the surface of the river. (Courtesy Chicago Historical Society, *Chicago Daily News* negatives collection, DN-0008827.)

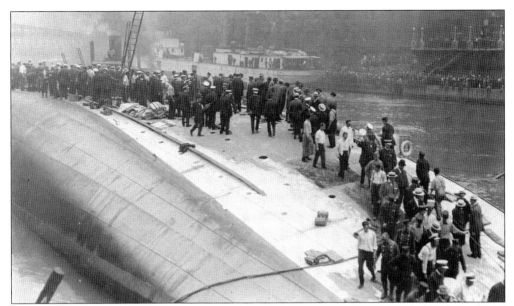

Personnel from the Chicago Fire Department (dark, double-breasted shirts and dark caps) and Chicago Police Department were immediately dispatched to the scene to coordinate the rescue efforts. Other police and fire personnel who were off duty heard the news and arrived quickly as well. They worked heroically for hours, even days. Patrolmen Fred Fisher and John Lescher were on duty at the Clark Street Bridge and used a rowboat to assist several passengers to safety. Fire Lieutenant James Rowley tied a lifeline around his waist and went through a porthole to assist several people trapped in a lower deck. (Courtesy *Eastland* Disaster Historical Society.)

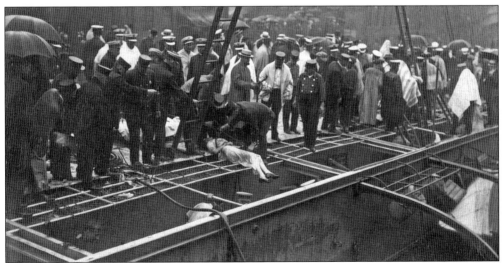

While the crew knew how to get off of the capsizing ship, the passengers did not, and many were imprisoned inside of the ship. "I watched curiously," recalled Mary Vogel, "as several rescue workers suddenly appeared with long ladders and began lowering them through the openings in the side of the boat. Up until that moment I had not given any thought to the possibility of there being people inside the sunken hull of the *Eastland*. Then suddenly I felt very sick." (Courtesy Chicago Historical Society, Jun Fujita collection, ICHi33128.)

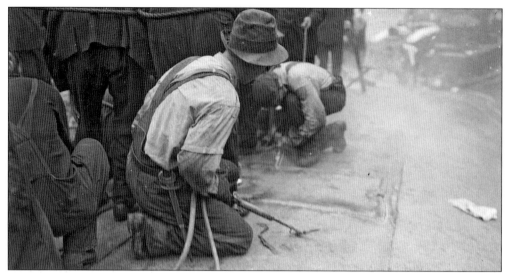

Those who were trapped inside the hull witnessed death as well as acts of heroism. They watched as exhausted women and children lost their grips and slipped down into the water. Survivor George Olinger described those minutes in the hull: "Men and women were floundering around as the water rose, and [they were] screaming. The men helped the women to places where they could cling until help arrived, but many sank during the first five minutes and did not come up. I kissed [my wife] Elizabeth and we made preparations to die." They then heard the tramping of feet up on the hull, and seconds later the portholes were opened by rescuers. Several welders working at nearby shops and job sites rushed to the scene with their oxyacetylene torches and cut holes in the overturned hull of the *Eastland*. Those trapped in the hull tried to remain calm as hot steel rained down upon them. (Courtesy Chicago Historical Society, *Chicago Daily News* negatives collection, DN-0064986.)

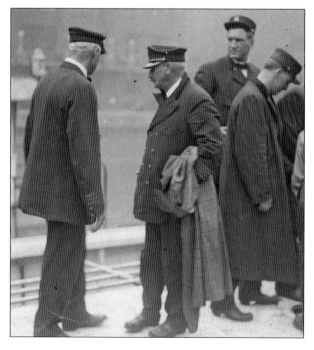

Captain Harry Pedersen (with coat in hand) objected to the work being performed by the welders. Incredulously, he ordered the welders to stop cutting holes in the hull, as they were "ruining his ship." This action further angered a crowd of people who had already been stirred by the captain's failure to properly command his ship. Those who observed this spectacle called for the captain to be lynched or drowned. Police, however, arrested Pedersen and took him into custody, a move that likely saved him from the mob's intended actions. (Courtesy Chicago Historical Society, *Chicago Daily News* negatives collection, DN-0065006.)

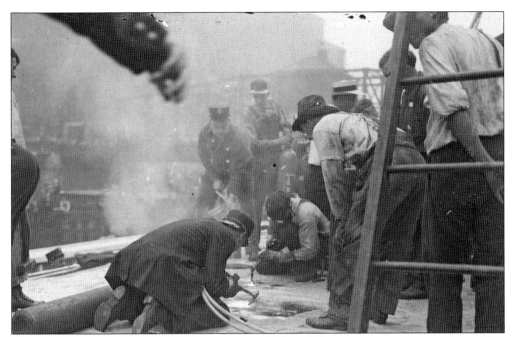

John Siwek, Elmer Nelson, John Zimmerman and Edward Zimmerman were among the welders whose flames pierced the steel hull of the *Eastland*. "He [the captain] told me to stop," said Nelson. "I did stop for a minute, but the police arrested him and I went back to work again. From the hole I helped to make in the hull we pulled three persons to safety." (Courtesy Chicago Historical Society, *Chicago Daily News* negatives collection, DN-0064987.)

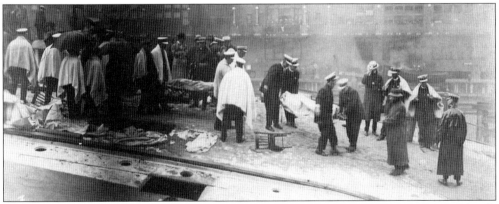

For the dozens of people who were trapped between the decks, time seemed to stand still. Minutes passed in what seemed like hours. Survivor J. V. Brown described the experience that he and others faced in the hold. "All this time I was swimming around—six or seven hours it seemed—although it probably wasn't over ten or fifteen minutes." Dozens of passengers were liberated once the holes (visible in photo) had been cut through the metal. One of these was Marie Linhart: "My fingers were all bruised and bloody but I held onto [the life preserver hook]. People were screaming and crying. A man laid down on the side [of the hull] up there and reached down and grabbed my hands and hiked me up. Looking down, all I could see was hair and hands and feet and picnic baskets and children crying. I thought I was gonna get torn back down, people were just grabbing and holding and trying to get out. My skirt was off, my shoes were off, my clothes were torn." (Courtesy *Eastland* Disaster Historical Society.)

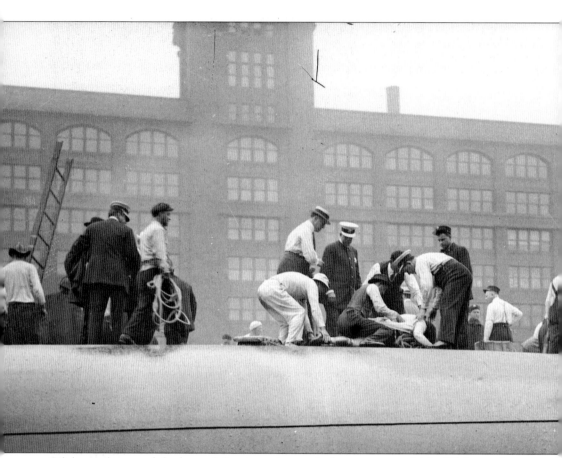

Of those who were *helped out* of the river, the <u>survival</u> rate was very high. Of those who were *pulled from* the river, the <u>revival</u> rate was very low. Most pulled from the river were dead, but a few showed signs of life. Western Electric nurse Helen Repa estimated that out of hundreds pulled from the river, only a few were revived. (Courtesy Chicago Historical Society, *Chicago Daily News* negatives collection, DN-0064945.)

Bodies were brought up from the hold faster than awaiting doctors and nurses could handle them. For anyone who had a pulse in their neck or even a whisper of a chance of surviving, Dr. Thomas A. Carter, chief police ambulance surgeon, would call, "Pulmotor!" The odd-looking respiratory apparatus was brought over to where the doctor huddled around a body, and then it was used to force water out of the lungs. (Donated by Lynn Steiner; courtesy *Eastland* Disaster Historical Society.)

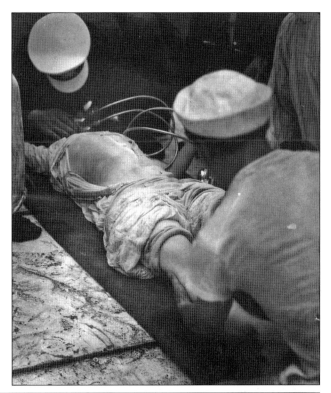

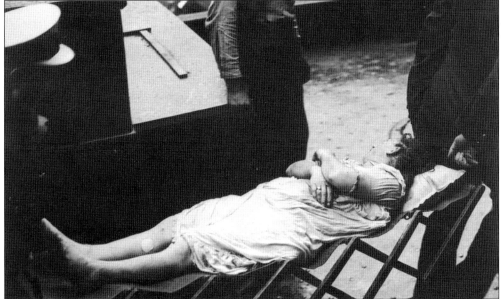

Many who survived the tragedy became sick after swallowing the filthy river water. "She ingested some river water and contaminates [raw sewage] and was very ill for nearly a year," Ben Jacobs recalled of his wife Hulda's experience in the river. Charles Agnos shared similar thoughts: "I drank that Chicago River water and —- ooohhh —- it was bad." The Chicago Department of Health administered hundreds of inoculations for typhoid fever. (Courtesy Chicago Historical Society, Jun Fujita collection, ICHi02052.)

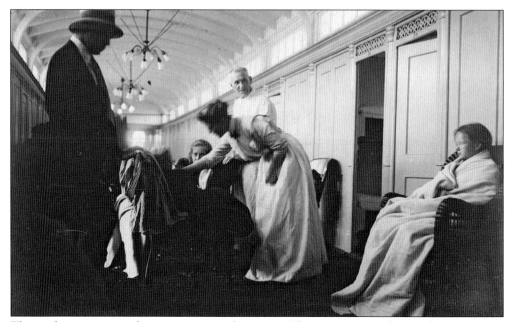

Those who were rescued went in various directions. They went to nearby warehouses, stores, hotels, and hospitals, including Iroquois Memorial, St. Luke's, and Franklin Emergency. Doctors and nurses comforted the survivors, wrapping them in blankets and administering medical care where it was needed. (Courtesy Chicago Historical Society, *Chicago Daily News* negatives collection, DN-0064937.)

Local stores, restaurants, and hotels opened their doors and offered blankets with hot coffee and soup. Telephones were in high demand as those who were rescued attempted to place calls home to advise their families of their status. But phones were hard to come by. "I don't remember how I got there," recalled William Cawnt, "but I was taken to one of the big Loop hotels nearby. I wanted to telephone my wife but there were long lines of people waiting for each telephone. A man told me to sit down and he would wait in line for me." (Courtesy Chicago Historical Society, *Chicago Daily News* negatives collection, DN-0064924.)

Thousands of people had descended upon downtown Chicago for the picnic. After the tragedy, and with no passenger manifest at hand, the status of these thousands was largely unknown. The recovered bodies of victims had been scattered throughout the Loop, and survivors were equally scattered throughout the greater Chicago area at hospitals, hotels, coffee shops, and the streets. Many survivors were en route to their homes as well, hopping an Elevated, streetcar, taxi, or other ride by a passing Good Samaritan. Compounding this were the hundreds who had friends or relatives on the boat, and were frantically trying to get some news of them. In response to the need for timely and accurate information, Western Electric established several information bureaus. This bureau was established in a vacant store at 214 N. Clark Street and was opened within 90 minutes of the onslaught of the tragedy. (Property of AT&T Archives. Reprinted with permission of AT&T.)

The Chicago Telephone Company equipped the information bureaus with telephones, at no charge. All phone calls that were placed, including long distance calls, were free. Names of those who were confirmed dead or alive were organized alphabetically in lists, while others were added to the list of those who were missing. The local newspapers received information from the Western Electric bureaus and published lists of the dead, surviving, and missing. These lists, however, were not always accurate. Survivor Bernard Beverley was listed among the dead; his wife was sent flowers by friends who saw the death notice in the newspaper. Clara Reisner survived and took a streetcar home. In the meantime, her father, brother, and fiancé went downtown to search for her. Clara, safe at home, was later listed among the missing, because her father could not find her. (Property of AT&T Archives. Reprinted with permission of AT&T.)

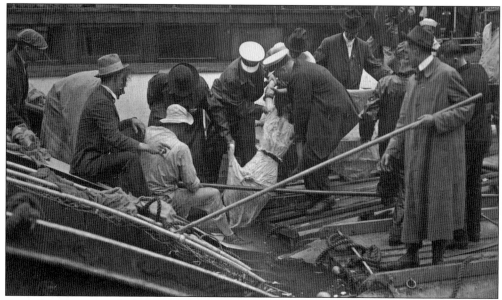

As each minute passed, the work of the rescuers shifted more and more from assisting survivors to recovering victims. "As the dead were recovered from the river or from the hold of the ill-fated ship, the scenes enacted were heart-rending. Women fell unconscious and strong men wept," said L. D. Brown. His comments were affirmed by Policeman Patrick Lally, who had assisted with the recovery of victims. Lally returned home at the end of the day, sat down in his chair and cried—it was the first time his family had ever seen him cry. (Courtesy Chicago Historical Society, Jun Fujita collection, ICHi32994.)

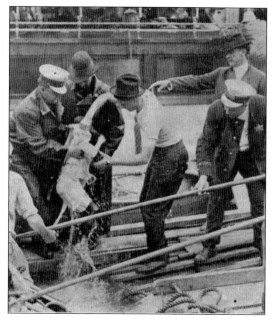

The tragedy affected rescuers and survivors alike, pushing many into shock and simply overwhelming others. "I found one man up a little alley nearby," recalled Helen Repa. "He was wandering up and down, with a ghastly, expressionless face, repeating over and over again, 'I lost them all, I lost them all.' His wife and three children were somewhere in the hold of the *Eastland*." Clark Greene recalled similar scenes: "We could not get near the docks but stood in the street while people passed us who had been rescued and could walk. Most were in tears, some hysterical, and one girl that I saw was actually crazed, she was soaking wet, hair hanging down, actually tearing her hair and screaming at the top of her voice something about her sister." (Courtesy *Eastland* Disaster Historical Society.)

The recovery process was hampered due not only to the water, but the tight, cramped quarters and all of the debris that had shifted when the *Eastland* rolled over. (Donated by Lynn Steiner; courtesy *Eastland* Disaster Historical Society.)

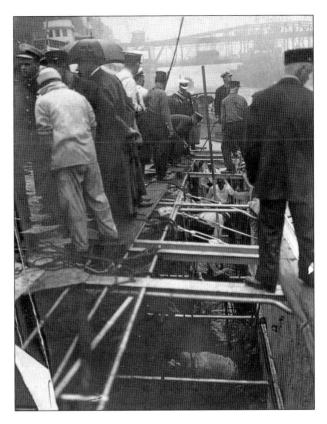

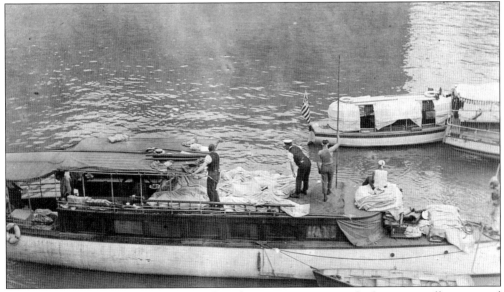

Many of the smaller boats that arrived at the scene to assist with the rescue efforts instead became floating hearses. As bodies were pulled from the river they were placed on the decks and covered, later being transported to shore to be transferred to one of the makeshift morgues. (Donated by the family of Grey Warrner; courtesy *Eastland* Disaster Historical Society.)

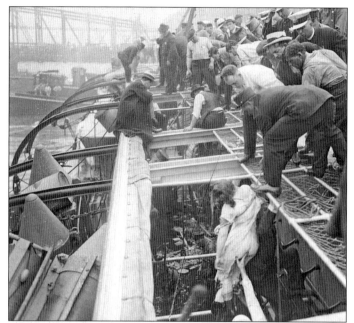

The majority of victims were young women and children. "It was a terrible sight to see those women and girls and children, who but a few minutes before had been standing on the decks of the *Eastland* happy and laughing, being taken out of the water dead or dying," said George Dubeau. (Courtesy Chicago Historical Society, *Chicago Daily News* negatives collection, DN-0064959.)

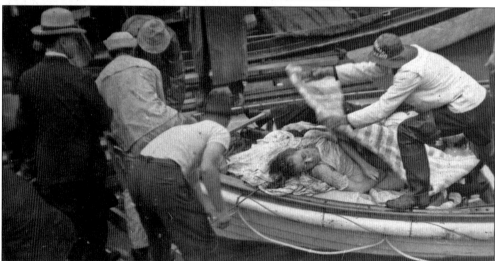

Although the coroner's official cause of death was "drowned," it was apparent that many people struggled after being thrust into a fight for their lives. Rose and Mary Janousek, sisters who survived, were scratched all down their backs from people trying to climb on them. "Summer gowns and finery torn to shreds, scratched faces, and clenched hands were the rule," reported the *San Francisco Examiner*. Several witnesses reported that the women, as a general rule, acted more calmly and bravely than did the men. "Women and children first? Not on your life! I saw men tear women and girls from where they were clinging to rails above the water in order to get positions of temporary safety. There was nothing like chivalry. Oh, if the men had only been as brave as the women, the loss of life would have been much less!" proclaimed Joe Lannon. True to Lannon's observation, survivor William Lukens sadly saw his wife pulled under to her death: "We were both holding onto [a bench]. Then somebody, fighting for a hold on our bench, grabbed [my wife] Barbara. She let go and drifted away, and she sank, looking straight into my eyes." (Donated by Lynn Steiner; courtesy *Eastland* Disaster Historical Society.)

Several volunteer divers assisted the policemen and firemen. Dan Robbins (photo) made trip upon trip into the scrambled mess between the vertical decks of the half-submerged *Eastland*. Over the course of the day he recovered dozens of victims' bodies. (Courtesy Chicago Historical Society, Jun Fujita collection, ICHi30723.)

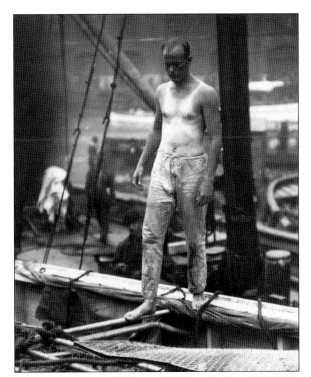

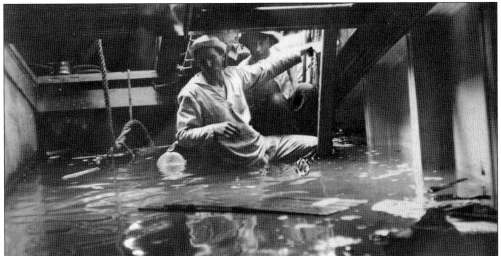

Throughout the day and into the evening, volunteer divers entered the dark, murky bowels of the ship, primarily in search of victims' corpses, yet hoping that they would find survivors. One such volunteer was a 17-year-old boy named Charles R. E. Bowles. An excellent swimmer with little to no fear of danger, "Reggie" (pronounced 'Reggae') arrived at the wharf, slipped into his swim trunks, and began exploring sections of the hull where professional divers could or would not go. He worked throughout the day and into the evening, constantly fighting self-inflicted fatigue. "Just let me rest a bit and I'll go back [into the ship]," Reggie pleaded with authorities. He brought 40 bodies to the surface and quit only when forced to do so. Veteran divers who witnessed his feats gave him the distinctive nickname, "The Human Frog." (Donated by Ken Glasener; courtesy *Eastland* Disaster Historical Society.)

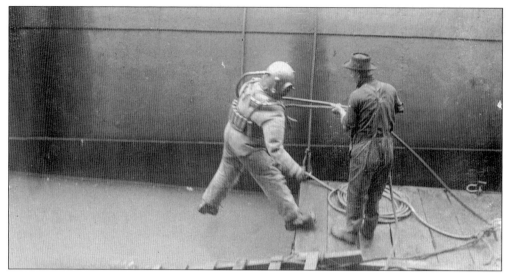

Professional deep-sea divers were also used to explore the hull of the ship. Equipped with underwater breathing apparatus, these divers could stay underwater for extended periods of time. Time and again—over the course of days—the divers donned their diving suits and plunged into the Chicago River, weighed down by lead-soled shoes, helmets, and slugs of lead over a shoulder or around the waist. (Courtesy Chicago Historical Society, *Chicago Daily News* negatives collection, DN-0064997.).

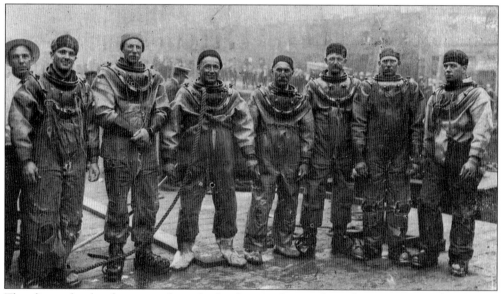

The divers fought their way through the heaps of water-logged scrap—picnic luncheons, parasols, pop cases, clothes, dolls, and teddy bears—items that were intended for picnicking and merrymaking. The divers in gear from left to right are William Deneau (unconfirmed), Iver Johnsen, unidentified, George Alfred Saunders Sr., Charles Gunderson, Harry Halvorsen, and Barney Sullivan. Hugh Brown, G. L. Field, Captain Fred Bildhauser, and Captain Dan Donovan were also among the divers who descended into the dirty river and the hull of death. (Courtesy *Eastland* Disaster Historical Society.)

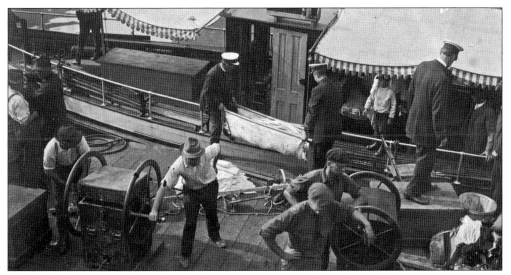

While the divers were busy down below, the activity on the surface of the river in support of the divers was hectic, too. Assistants, or tenders, played vital roles, though much less risky than that of the divers. They literally were the lifelines to the divers below, hand-pumping oxygen through the breathing tubes and monitoring the signal lines. (Courtesy Chicago Historical Society, Jun Fujita collection, ICHi33122.)

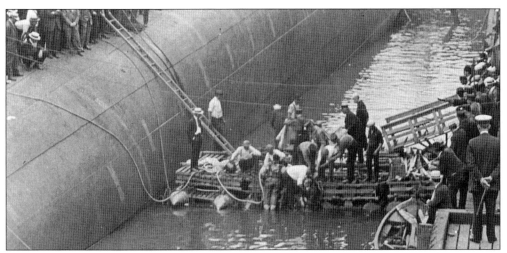

The divers' exploits entailed great danger, and their assistants on the river's surface were held in suspense many times as the divers fought for their lives while doing their jobs. "I was down in the dance deck when I got mixed up with some stanchions," said diver Charles Gunderson. "I had jerked the signal cord a half dozen times before I discovered it must be fouled above—and I hadn't started jerking it until I was satisfied I couldn't get free by myself. It was as tight a place as I had been in. And then I made another discovery. My air tube had fouled, too, and I couldn't breathe. I was down there alone without air. Those above had no way of knowing what I was up against. It was up to me to live or die. I kicked until I must have been blue in the face, and then, all of a sudden, I was free. I took a step and the signal cord was cleared. Air began to come through the tube, but not enough of it to do me much good. You can bet I gave the [signal] cord a jerk!" Charles Gunderson lost consciousness on the upward journey, but recovered a half hour later. (Donated by the family of Grey Warrner; courtesy *Eastland* Disaster Historical Society.)

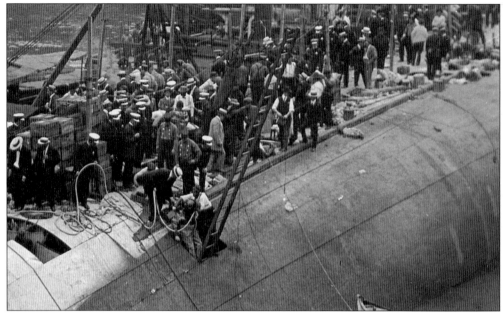

The divers explored every part of the overturned ship that was accessible to them. Their work required considerable skill on account of the hazards connected with the daring work. It also required considerable nerve. In this photo, a diver is assisted into the hold of the *Eastland* through one of the holes cut by welders in the overturned hull. (Donated by the family of Grey Warrner; courtesy *Eastland* Disaster Historical Society.)

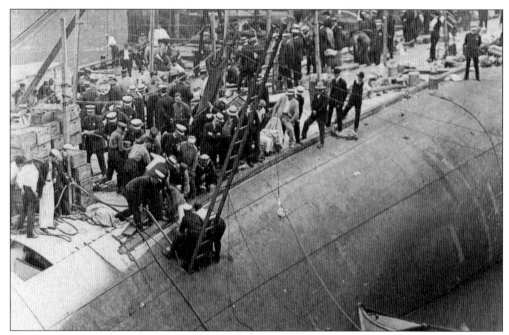

Moments later the diver brought a body back to the hole to be extricated from the ship. Among other tasks, the divers were called upon to break into the various rooms within the interior of the ship. (Donated by the family of Grey Warrner; courtesy *Eastland* Disaster Historical Society.)

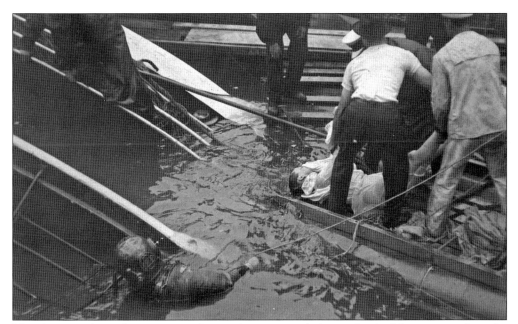

The divers withstood gruesome sights as they removed those who had been trapped in the sealed chambers and had drowned. One passenger was discovered alive in the hold of the *Eastland* by diver Harry Halvorsen as late as Tuesday afternoon. This man, unfortunately, died minutes after being pulled from the ship. He had spent three days in the water in complete darkness, no one aware that he was trapped inside the hull. (Donated by Lynn Steiner; courtesy *Eastland* Disaster Historical Society.)

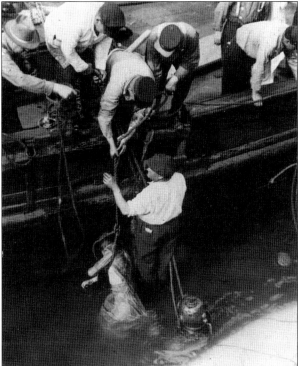

The divers' work was not just that of exploring the hull. Tugs were deployed to assist eight divers as they combed the bed of the Chicago River for victims' bodies that had drifted downstream. The divers worked from the Clark Street bridge to as far west as the Wells Street bridge—two full city blocks away. As the days passed, several bodies were recovered from this methodical search. (Courtesy Chicago Historical Society, Jun Fujita collection, ICHi27836.)

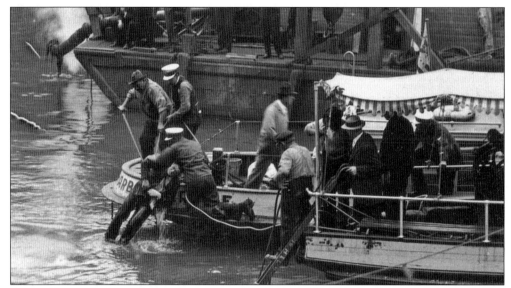

As quickly as a body was located it was seized with grappling hooks and brought to the surface. "There's one!" would be the cry. More times than not, this would be followed by the call, "It's a woman!" (Donated by Ken Glasener; courtesy *Eastland* Disaster Historical Society.)

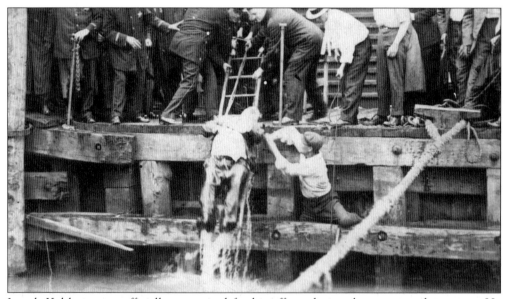

Joseph Kuhlman was officially recognized for his efforts during the rescue and recovery. He recalled the experience: "You can't imagine the full horror of it. I have never read nor seen such a sight. More than half of that huge crowd of merrymakers had no chance for life. In our rescue work we used pike poles with which we would fish for bodies and then tie a rope around the body and have it pulled up. The victims were hurried out this way and rushed to the street and the pulmotor. All the streets, wharves, and commission houses were hospitals or morgues that day. I was using a 15-foot pike pole and at one time knew I had a body hooked but couldn't lift it. I signaled for help and was let down with a rope around my waist. There I found two women and a baby locked in a death grip." (Donated by Lynn Steiner; courtesy *Eastland* Disaster Historical Society.)

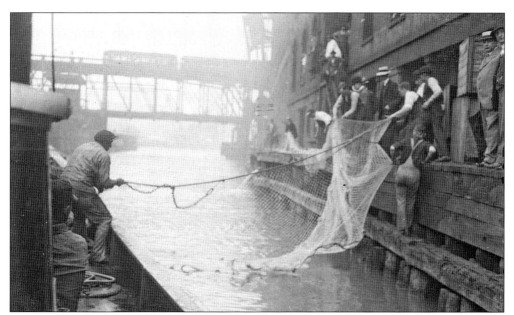

"Nets were thrown across [the river] at several points below where the accident occurred in order to catch the bodies as they were being carried down towards the can, and frequent examinations of these nets were made by divers," noted L. D. Brown (Courtesy Chicago Historical Society, *Chicago Daily News* negatives collection, DN-0064984.)

To handle the recovery of victims as they were pulled from the river, a floating morgue was erected on a barge. The American flag was flown at half mast. (Courtesy Chicago Historical Society, *Chicago Daily News* negatives collection, DN-0065010.)

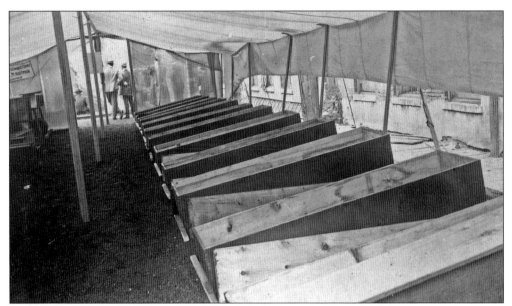

The interior of the floating morgue was filled with rows of coffins. The morgue was a tent structure with an earthen floor. (Courtesy Chicago Historical Society, *Chicago Daily News* negatives collection, DN-0064994.)

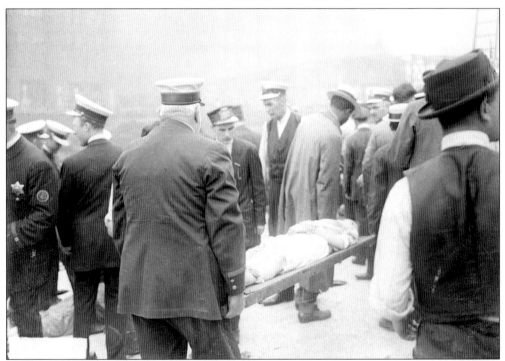

"There was a constant stream of bodies being brought up from the hull and dragged out of the river, and I think there must be several hundred yet in the river," said George Duneau. As fast as the bodies were brought out of the hull they were laid on stretchers and covered with blankets. (Courtesy Chicago Historical Society, *Chicago Daily News* negatives collection, DN-0064953.)

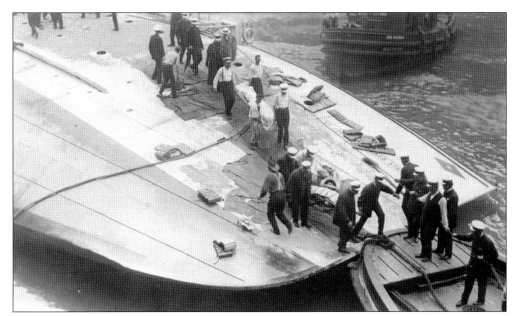

Chicago's emergency personnel labored tirelessly. "That silently sad procession of policemen and firemen and others bearing in fours," wrote Harlan Babcock, "each a body on a dripping stretcher—mute evidence of the terrible toll of the waters. Solemnly, the stretcher bearers walked down the hull of the steamer onto the dock with their inanimate burdens of humanity that a brief half hour or hour before had scurried laughing to the death craft." Stretcher after stretcher of dead weight was carried through the drizzling rain across the hull of the *Eastland*… (Courtesy *Eastland* Disaster Historical Society.)

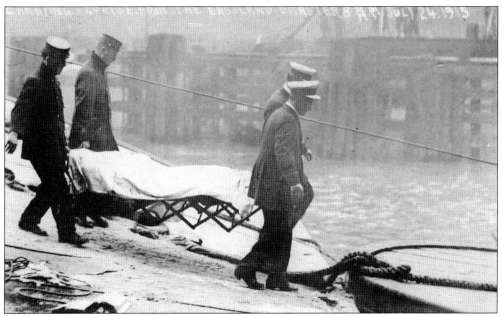

…up onto the stern of the *Kenosha*… (Courtesy *Eastland* Disaster Historical Society.)

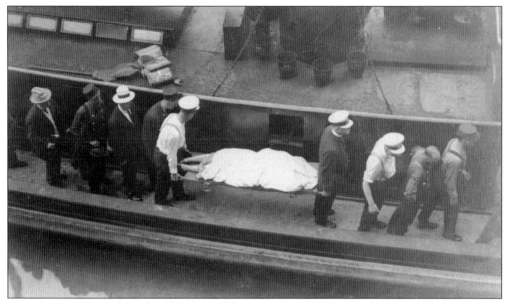

… and across the deck of the *Kenosha*… (Courtesy *Eastland* Disaster Historical Society.)

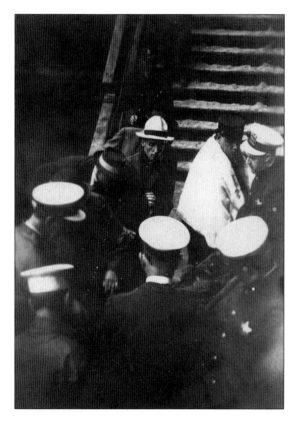

…before stepping onto the wharf. Once there, a flight of wooden stairs was climbed to reach the street level of the Clark Street Bridge… (Courtesy *Eastland* Disaster Historical Society.)

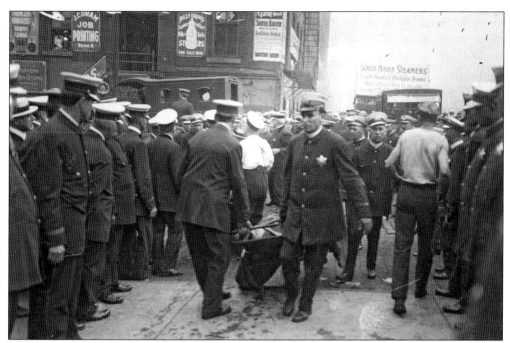

…before working through the crowds for transport to one of the makeshift hospitals or morgues. The stream of bodies was continuous with breaks only when rescuers had to stop and wait for the stretchers to be emptied and returned. (Courtesy Chicago Historical Society, *Chicago Daily News* negatives collection, DN-0064956.)

One report showed that Chicago fireman Fred Swigert worked for several hours pulling bodies from the hold of the *Eastland*. Later, a diver handed him the body of a little girl which he placed on a stretcher. He looked closely at the child, gasped and fell unconscious—it was his own daughter. (Courtesy Chicago Historical Society, *Chicago Daily News* negatives collection, DN-0064958.)

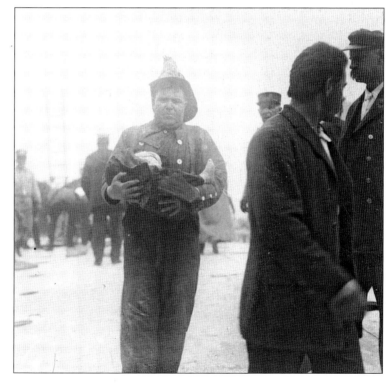

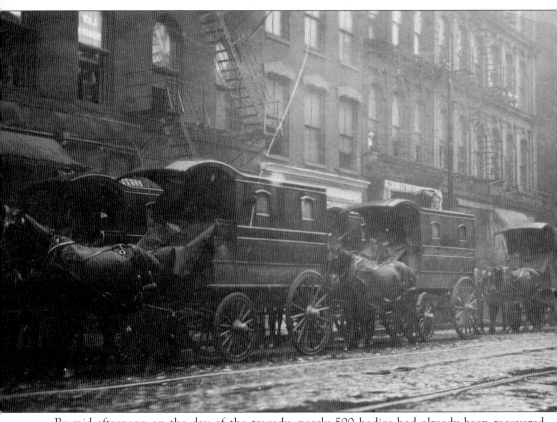

By mid afternoon on the day of the tragedy, nearly 500 bodies had already been recovered. Horse-drawn wagons were used to transport the victims' bodies to the makeshift morgues. The city of Chicago experienced a shortage of these types of vehicles. (Courtesy *Eastland* Disaster Historical Society.)

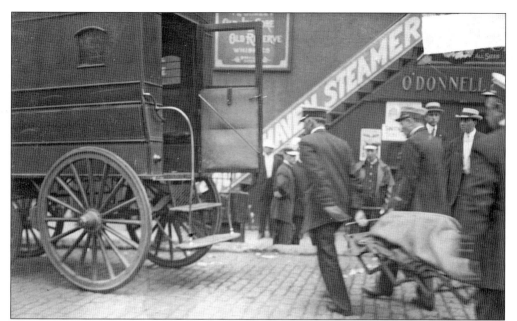

Individuals and businesses donated the use of their vehicles to help handle the hundreds of bodies. Mandel Brothers loaned two wagons and an automobile truck; Carson, Pirie, Scott & Company loaned one truck; and the Adams Express Company sent all of their available wagons. (Courtesy Chicago Historical Society, *Chicago Daily News* negatives collection, DN-0064955.)

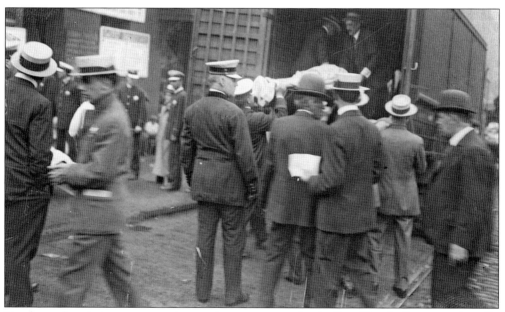

Trucks and ambulances were also used to transport the bodies. The bodies were initially distributed among several locations, including the Reid, Murdoch & Company Building, P. J. Gavin's Undertaking, Western Casket & Undertaking, Central Undertaking Company, and Jordan's, Carroll's, Sbarbaro's, Maloney's, and Arntzen's Undertaking establishments, as well as the Jefferson Park Hospital. (Courtesy Chicago Historical Society, *Chicago Daily News* negatives collection, DN-0064957.)

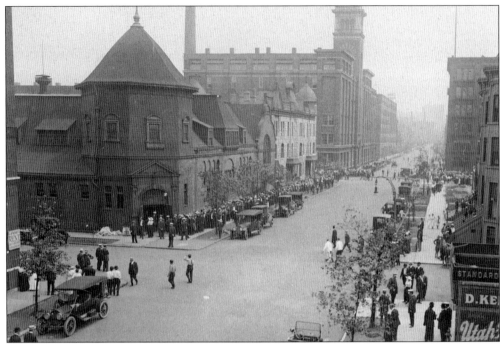

As the number of bodies grew and before the situation got out of control, Cook County Coroner Peter Hoffman procured the use of the Second Regiment Armory to serve as the central morgue. The Armory was located nearly one-and-a-half miles west of the disaster scene on Washington Boulevard at Curtis Street. (Courtesy *Eastland* Disaster Historical Society.)

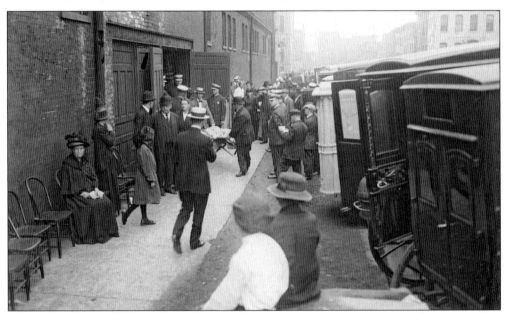

Bodies were continually brought to the central morgue throughout the day and for the days that followed. As fast as the bodies were brought up out of the river by the divers they were brought to the central morgue. (Courtesy Chicago Historical Society, *Chicago Daily News* negatives collection, DN-0064991.)

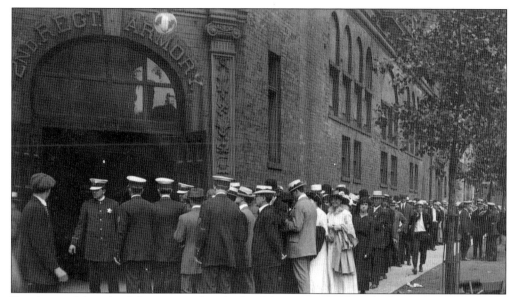

Families and friends of the victims, hundreds of them, stood in line for hours waiting to enter the armory in order to identify their loved ones. Other family members waited anxiously back at home. Neighborhood friends Blanche Homolka and Alice Quinn went to their local streetcar stop. "We were hoping that our sisters would be on one of the streetcars that were coming from the Loop," said Blanche. "[The streetcars were] filled with people, some of them wet. And Alice and I sat on the curb and watched and waited and hoped. But our sisters never came back." Both Blanche's sister Caroline and Alice's sister Anna perished. (Courtesy *Eastland Disaster Historical Society*.)

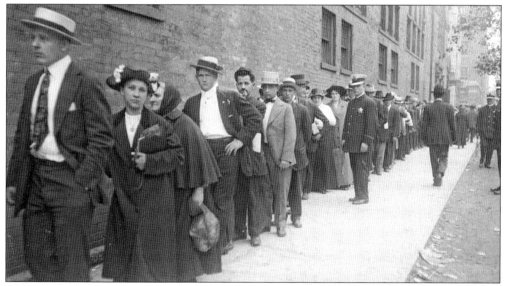

Police were kept busy not only controlling the emotional crowd but also keeping the morbidly curious—people who were not seeking to identify a relative or friend—out of the building. The crowds waited until very late in the evening. The doors were finally opened to let them in around midnight. (Courtesy Chicago Historical Society, *Chicago Daily News* negatives collection, DN-0064992.)

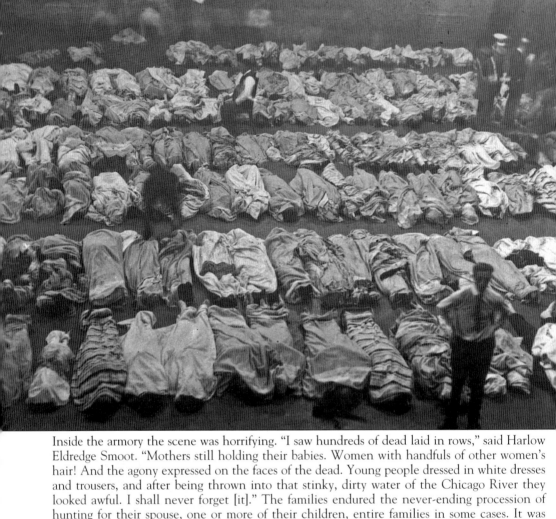

Inside the armory the scene was horrifying. "I saw hundreds of dead laid in rows," said Harlow Eldredge Smoot. "Mothers still holding their babies. Women with handfuls of other women's hair! And the agony expressed on the faces of the dead. Young people dressed in white dresses and trousers, and after being thrown into that stinky, dirty water of the Chicago River they looked awful. I shall never forget [it]." The families endured the never-ending procession of hunting for their spouse, one or more of their children, entire families in some cases. It was heart-rending and impersonal—utterly incomprehensible. Many people did not know whether their loved ones had died or survived. This included Mary Braitsch, who had been with her husband and all five of their children on the *Eastland* when it rolled over. Mary was holding her six-month-old daughter in her arms when she was thrown into the water. The next day when no one returned home, she sent her brother, Otto Brandt, to the morgue to search for her family. Her parting instructions to her brother were: "I know that at least one of my babies must be alive. You must come back and tell me that at least one has been spared. You must bring one of them back alive with you tonight." Otto found all five Braitsch children, their silent forms lying on the floor of the Second Regiment Armory. A big and strong man, he broke down. With tears flowing he uttered, "I've got to go home and tell her [my sister]. I should have gone home long ago, but I cannot tell her that all have gone." Mary's husband John also perished, leaving Mary as the sole surviving member of this family of seven. (Quote courtesy of Cornell University Library, Division of Rare and Manuscript Collections, Lucien L. Nunn collection, Collection Number 37-4-1770, Box 48, folder 22, item 25 of 57; Photo courtesy Chicago Historical Society, Jun Fujita collection, ICHi33125.)

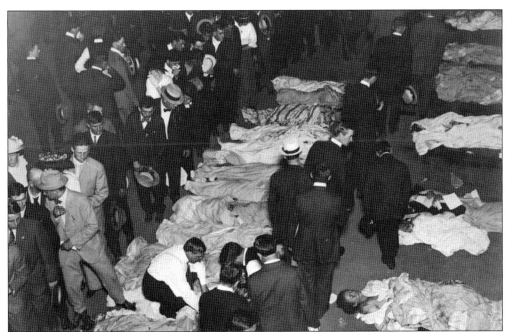

The grueling identification process in the morgue led to the double identification of several of the victims—two or more families claiming a single body as their loved one. Josephine Sindelar's body was one of several that were identified by two different grieving families. The first identification was a mistake that fortunately was questioned by Josephine's mother, Clara Dolezal, before the body was removed from the morgue. Clara recognized the suede shoes that protruded from the blanket covering Josephine's body. Clara cried out: "This is Josie! This is Josie!...but if you doubt me, look into her mouth. Josie has two small rims of gold on her front teeth." The mouth was opened—two narrow rims of gold were found. (Courtesy Chicago Historical Society, Jun Fujita collection, ICHi02047.)

The continual flow of bodies being brought into the morgue in many instances also necessitated families having to make repeat trips through the ghastly procession. Edward Stamm, 67, survived but lost his wife Anna, daughter Cora Hipple, and two grandchildren, Hazel and Clifford Hipple, 13 and 8, respectively (photo). Edward recalled that "they found Anna about 5 o'clock that day, and Hazel and Clifford about 9:30 a.m. the next day, and Cora about 2:30 that afternoon." As the procession continued hour after hour and day upon day, canvassed sheets were stretched around tables set up for embalmers to do their work in the corners of the armory. Most of these professionals had little, if any rest at all, for days. (Courtesy Earl Gallas, great-grandson of Edward Stamm.)

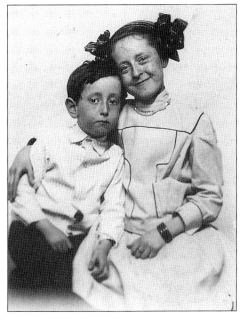

PHONE CANAL 1225 *Lawndale 3101* 242

OTTO MUCHNA

POHROBNÍK A BALSAMOVAČ

Půjčuje kočáry
ku pohřbům,
svatbám a pod.
příležitostem

UNDERTAKER & EMBALMER

Carriages fo
let for funerals
and all other
purposes : :

2716 S. CENTRAL PARK AVE. **CHICAGO**

Otto Muchna was one of the many undertakers who worked round the clock—for days—keeping up with the seemingly endless number of bodies. The coroner's records show that he performed the services for at least 15 victims, including Edward and Anna Zobac. Otto performed the undertaking while his wife, Mary, made the bodies presentable by dressing the hair and doing the makeup. The Muchnas' funeral chapel on South Central Park Avenue did not have enough room for all of the bodies brought there by the horse-drawn carriages. The driveway was enclosed and it, together with the garage, provided additional room. Funeral professionals experienced shortages of every kind. "There was a shortage of coffins and so when my dear sister Carrie was brought home, they had placed her on a sort of wicker sofa," offered Blanche Homolka. Shortages of funeral cars and hearses were also experienced. (Courtesy family of Otto Muchna.)

The owners of Hitzeman Funeral Home recalled: "We took care of 26 bodies, which had to be embalmed and taken to their own homes within two or three days." Western Electric paid for the funeral expenses, alleviating a huge burden from the families. The Company also paid for the transportation costs for families who were buried out of town. One such family was that of Mrs. Mary Braitsch, whose entire family—her husband and five children—were buried together in New York. (Courtesy Ivins-Moravecek Funeral Home.)

The grave digging staffs at local cemeteries were overwhelmed. Graves were dug by hand—there were no backhoes—taking two men four hours each to dig a single grave. Nearly 150 graves had to be prepared at Bohemian National Cemetery (Chicago) alone. Ordinarily, there were four grave diggers on staff at the cemetery. During the week following the disaster, 52 men were employed, each working more than 12 hours a day. (Courtesy Bohemian National Cemetery Association.)

For several days following the tragedy, funeral processions became a part of many people's daily routines. Family members, neighbors, and friends carried floral arrangements and wreathes, leading the pallbearers through the muddy city streets. "All that week it was just like tears falling from the sky. It was cloudy and dreary, and the shops were closed down and everyone was mourning," said survivor Frank Blaha. This funeral procession was that of Frances Nowak, 19, and her brother Floryan, 17. (Courtesy Chicago Historical Society, *Chicago Daily News* negatives collection, DN-0064961.)

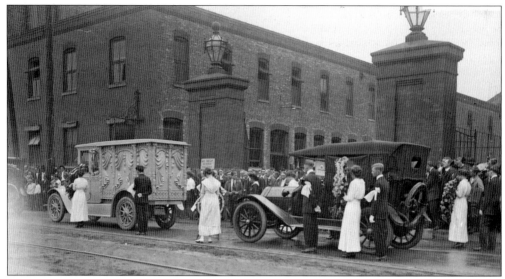

"Some families," recalled a member of Grace Lutheran Church, "had as many as two or three lying in caskets in their homes. For three days and three nights we would go from house to house to pay our respects and express our sympathy and offer our help. The church bells tolled all day long. One funeral after the other would leave the church. Since it was impossible to get sufficient hearses and carriages, trucks were also used to take some of the bodies to the cemetery. It was also hard to get caskets." There were so many funerals that Marshall Field & Company loaned 39 of their company auto trucks for the funeral processions. Other firms loaned their company vehicles as well, including the Illinois Athletic Club and Chicago Athletic Club. (Courtesy Chicago Historical Society, *Chicago Daily News* negatives collection, DN-0064960.)

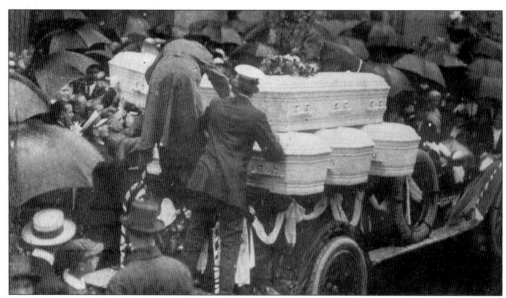

The Sindelar family was the largest of the 22 families that were completely wiped out. Lost were George and Josephine Sindelar, their five children, and Mrs. Sindelar's sister, Regina Dolezal. The photo shows the Sindelar caskets outside the Masonic Hall during the funeral. (Courtesy *Eastland* Disaster Historical Society.)

While individual families were devastated at the loss of one or more loved ones, many church families were also devastated, with some losing several dozen from among their congregation. "The bereaved at Grace Lutheran Church," said Rev. Henry Boester, the pastor at Grace, "bore the shock of the disaster as well as could be expected under the circumstances. It was, indeed, a great shock to the whole congregation, and, even though the faith of the members of the families who had lost a loved one or more in the disaster was sorely tried, my observation was that they found much needed comfort and strength for such a time as that in the Word of God, which I was privileged to bring them." (Courtesy St. Mary of Czestochowa, Cicero, Illinois.)

				48

Record of Interments.

Date of Death & Burial.	Names of Persons Interred.	Place of Birth.	Age.
24 VII.—28 VII.	Wład. Rakowski.		1/6
24 VII.—28 VII.	Franc. Hajduk.		18
24 VII.—28 VII.	Alicya Frydrych.		18
24 VII.—28 VII.	Wład. Latowski		24
24 VII.—28 VII.	Aniela Latowska.		27
24 VII.—28 VII.	Marya Wróblewska		3
24 VII.—28 VII.	Anna Kubiak		17
24 VII.—28 VII.	Józefa Szymańska		17
24 VII.—28 VII.	Agnieszka Ignaszak		17
24 VII.—28 VII.	Antonina Ignaszak		21
24 VII.—28 VII.	Fra. Siedlecka		17
24 VII.—28 VII.	Miecz. Szałaciński		17
24 VII.—28 VII.	Ignacy Leonarczyk		16½
24 VII.—28 VII.	Marya. Ceranek		17
24 VII.—28 VII.	Stella Malik		18
24 VII.—28 VII.	Marya. Malik		21
24 VII.—28 VII.	Anna Borkiewicz		17
24 VII.—28 VII.	Tom. Pilarski		25

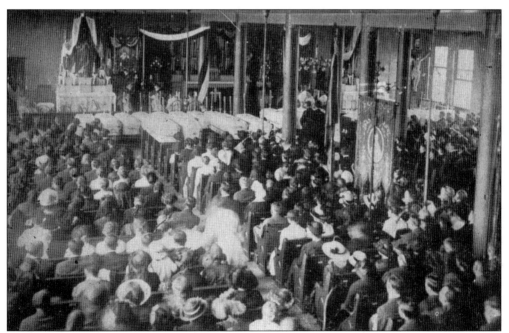

Pastors and priests performed dozens of funerals held in churches throughout the greater Chicago area. This memorial Mass was held in the combination church/school building at St. Mary of Czestochowa. White caskets for 29 of its parishioners lined the front of the church, so many that they had to be laid across the first several rows of pews. (Courtesy *Eastland* Disaster Historical Society.)

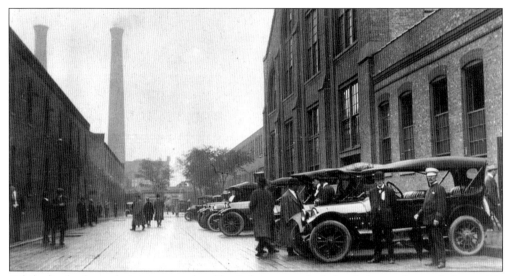

While the dead were being recovered and buried, measures had already been taken to help provide relief to the families of the victims. The day of the tragedy, Western Electric established two relief bureaus at its Hawthorne Works facility. To provide immediate help to dependents of Western Electric employees who had lost their lives, fleets of automobiles were assembled to expedite the travel required to administer the relief work—providing finances for rent, food, mourning clothes, and cemetery charges. Instructions given to the case workers were simple: "Give prompt relief. Ask questions next week." The private cars of more than 60 Hawthorne Works employees were loaned during the week after the tragedy. The American Red Cross established a relief station at the Hawthorne Works for those families of victims who were not Western Electric employees. (Property of AT&T Archives. Reprinted with permission of AT&T.)

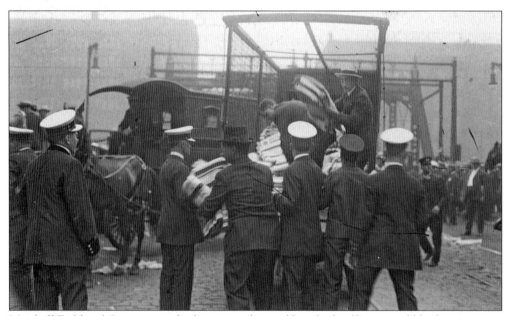

Marshall Field and Company and other stores donated hundreds of linens and blankets to cover the victims and to warm the survivors. (Courtesy Chicago Historical Society, *Chicago Daily News* negatives collection, DN-0064952.)

Wednesday, July 28, was officially designated as a day of mourning by Chicago. "The whole city has been plunged into mourning, and for many years Chicago will look back on today as one of the most terrible in its history," said L. D. Brown. Drapes were hung at City Hall to commemorate those whose lives were lost. (Property of AT&T Archives. Reprinted with permission of AT&T.)

"By a decree of the Cicero Town Board, July 28 was set aside as the day for a townwide funeral. All stores and plants were ordered to close at 9:00 a.m.," recalled Frank Houdek. The Hawthorne Works' gates were draped in mourning for those employees who died. (Property of AT&T Archives. Reprinted with permission of AT&T.)

A relief fund for the victims' families was established by the City of Chicago, to be administered by the American Red Cross. Nearly $400,000 was raised by donations from thousands of individuals and companies. Here, the streetcar union presents a check to the relief fund for $5,000. One local boy worked an entire week selling newspapers, donating the one dollar he had earned to the relief fund. Western Electric immediately allocated $100,000 toward relief of the victims' families. Over on Addison and Clark at Weeghman Park (later Wrigley Field) all proceeds from the baseball game held Thursday, July 29, were donated to the relief of the victims. Admission was paid not just by the fans but by everyone who was at the ballpark, including the players, coaches, and umpires. (Courtesy Chicago Historical Society, *Chicago Daily News* negatives collection, DN-0065008.)

While nearly $500,000 was raised between Western Electric and the private sector, the victims' families looked to the courts for appropriate compensation from those to be held accountable for the deaths. To help determine who should be held accountable, Coroner Peter M. Hoffman convened a jury (photo) hours after the *Eastland* rolled onto its side. President Woodrow Wilson sent Secretary of Commerce William Redfield to initiate the federal government's investigation. Several other inquiries were held, but they might just as well have not been conducted—no damages were paid by the courts to the victims' families. The Eastland claimed nearly 850 innocent lives in a tragedy of enormous magnitude. The results (or lack thereof) from the criminal and civil actions trivialized the value of the lives of the victims and made a farce of the handling by the authorities. Karl Marx once said: "History repeats itself, first as tragedy, second as farce." No truer words could have been spoken with respect to the court actions that stemmed from the *Eastland* Disaster. (Courtesy Chicago Historical Society, *Chicago Daily News* negatives collection, DN-0064983.)

Eight

THE CAUSE AND THE END

"There is no wisdom equal to that which comes after the event."
—Geraldine Jewsbury

There are many popular theories as to what caused the *Eastland* to capsize. Did the tug *Kenosha* pull the *Eastland* over? Was there a sudden rush of people to the port side of the ship? Was the ship's keel resting on the mud and debris at the bottom of the river? The answer to each of these questions is "no"—none of these theories is supported by historical evidence. So what did cause the *Eastland* Disaster? I believe that there was no single cause, an opinion that I base largely upon the research done by George Hilton as published in his book, *Eastland: Legacy of the Titanic*. Instead, the *Eastland* capsized due to the cumulative effects of several events. No "magic bullet," but instead, the "straws (six are listed on the next page) that broke the camel's back."

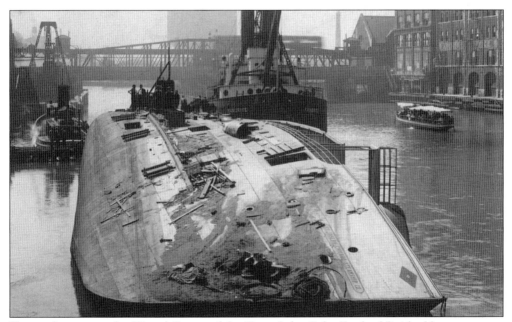

Known for years as the "Speed Queen of the Great Lakes," the *Eastland* finished her passenger-carrying career as a broken and beaten shell of her former glory. (Courtesy Betty Hogeorges, daughter of John B. McFarlane.)

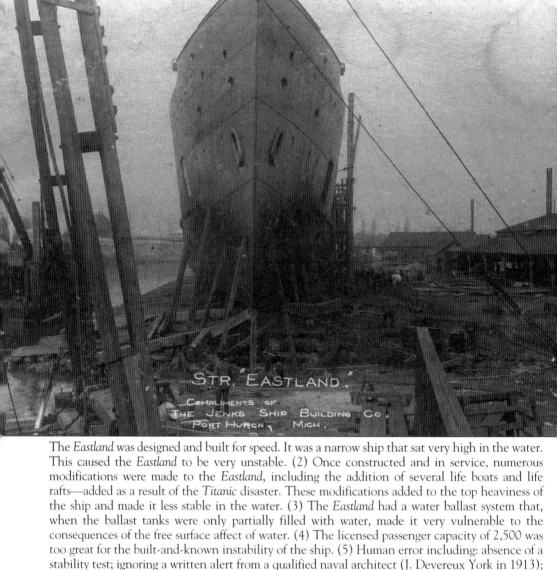

STR. "EASTLAND."

COMPLIMENTS OF
THE JENKS SHIP BUILDING CO.
PORT HURON, MICH.

The *Eastland* was designed and built for speed. It was a narrow ship that sat very high in the water. This caused the *Eastland* to be very unstable. (2) Once constructed and in service, numerous modifications were made to the *Eastland*, including the addition of several life boats and life rafts—added as a result of the *Titanic* disaster. These modifications added to the top heaviness of the ship and made it less stable in the water. (3) The *Eastland* had a water ballast system that, when the ballast tanks were only partially filled with water, made it very vulnerable to the consequences of the free surface affect of water. (4) The licensed passenger capacity of 2,500 was too great for the built-and-known instability of the ship. (5) Human error including: absence of a stability test; ignoring a written alert from a qualified naval architect (J. Devereux York in 1913); corporate focus of maximizing profits; and arrogance (and/or ignorance) of the captain and crew in their ability to operate the ship. (6) Lastly, and most unfortunately, human trust. The Western Electric Transportation Committee and the passengers assumed—rightly—that their safety was assured by others (the government and licensed professionals who owned and operated the vessel). Western Electric, publicly recognized for years for its achievements in the field of safe-guarding the lives of its employees while at work, summed this up the best in the August 1915 edition of the *News*: "We men and women have been surrounded by every known preventive of accidents. We have worked in buildings proof against fire, on machines protected against liability to injure us, within call of medical and hospital service. Indeed, our lives have been made safer at our work than in our homes or at our play." (Courtesy Michigan Maritime Museum.)

What became of the ill-fated *Eastland*? The task of righting the ship took two weeks. Contracted workmen relieved the *Eastland* of as much weight as possible. They cleared away the inside of the hull, tore out bulkheads, and removed the coal and mud that had settled on the port side of the ship. The *Eastland* was then made watertight and several hundred tons of water was pumped out of the interior of the ship. (Courtesy Chicago Historical Society, *Chicago Daily News* negatives collection, DN-0064972.)

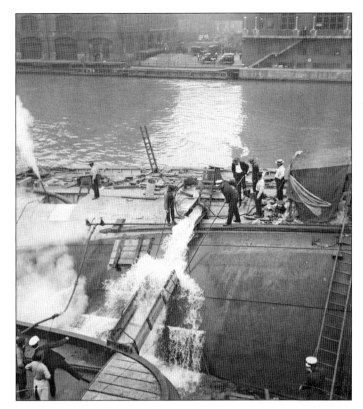

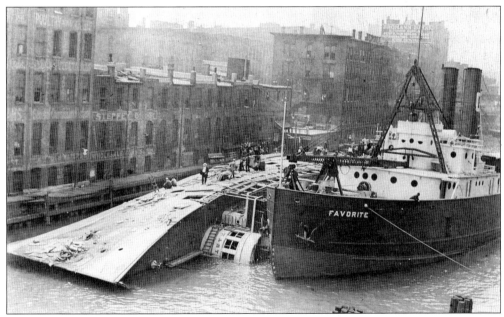

The *Favorite*, a 181-foot salvage vessel owned by the Great Lakes Towing Company, was one of the two primary vessels used in the righting operations. Cables were run from the *Favorite*, under the water and around the *Eastland*, and secured to the starboard (above water) side of the *Eastland*. (Donated by the family of Grey Warrner; courtesy *Eastland* Disaster Historical Society.)

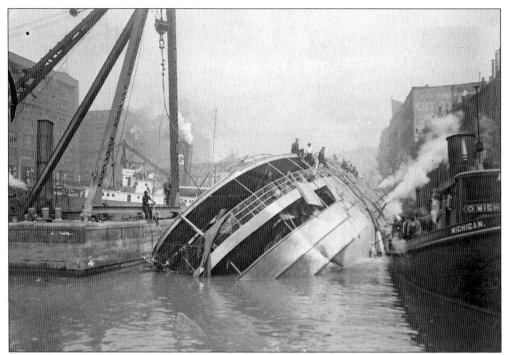

A 100-foot pontoon boat that carried a hoisting apparatus was the other primary vessel used to return the *Eastland* to an upright position. It, too, had cables run under the water and around the *Eastland* to its starboard side. (Courtesy Chicago Historical Society, *Chicago Daily News* negatives collection, DN-0064976.)

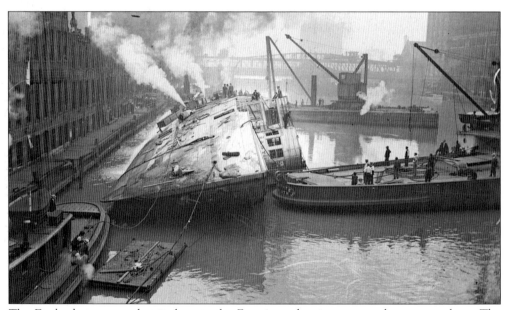

The *Eastland* was moored at its bow to the *Favorite* and at its stern to the pontoon boat. The engines of the two vessels then drew up their cables. (Courtesy Chicago Historical Society, *Chicago Daily News* negatives collection, DN-0064980.)

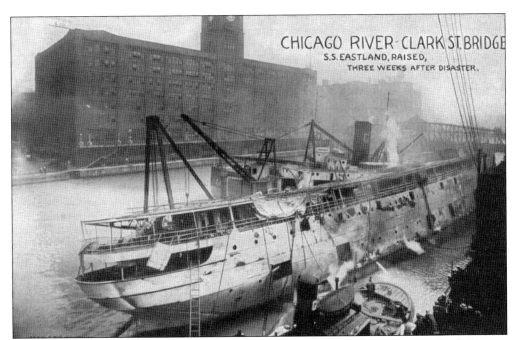

The *Eastland*, after considerable time and effort, was righted. (Courtesy *Eastland* Disaster Historical Society.)

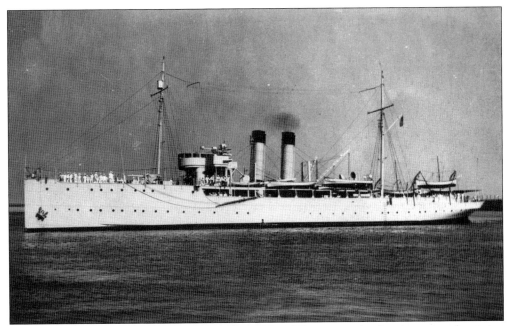

The *Eastland* was later purchased by the Illinois Naval Reserve and refitted as a naval training vessel. Renamed the USS *Wilmette*, the ship performed admirably on the Great Lakes for 30 years until its decommission in 1946. The *Wilmette* was sold and broken up for scrap in 1947, and what was once the "Speed Queen of the Great Lakes," ceased to exist. (Donated by John Azevedo; courtesy *Eastland* Disaster Historical Society.)

What became of the annual Hawthorne Works employee picnic? Once the funerals and burials were completed, people returned to work. Individuals and families picked up the pieces and went on with their lives as best as they could. And although the 1915 excursion and picnic were never held, the *Eastland* Disaster did not end the annual summer entertainment for employees at the Hawthorne Works. The Hawthorne Club returned to its annual summer merriment, with some revisions. (Courtesy Ron Steinberg and Lucent Technologies Inc./Bell Labs.)

Instead of holding an excursion and picnic, the Hawthorne Club called their summer extravaganza an "outing." Instead of being held across Lake Michigan at Michigan City, Indiana, it was held at Riverview Amusement Park in Chicago (home of the famous Shoot-the-Chutes and other rides). The event was moved from being held in late July to early August. What didn't change was the enthusiasm, merriment, and attendance—over 6,000 people attended the outing in 1917. (Courtesy Ron Steinberg and Lucent Technologies Inc./Bell Labs.)

Nine

FATE OR FAITH

"Come on Willie, we'll have a good time."
—unidentified friend of Willie Guenther

The fate of many people's lives was determined earlier in the morning on the day of the disaster. For many, it was a very simple act or casual decision that resulted in a change in destiny. Many were spared because they did not arrive at the docks in time to board the *Eastland*. Hugh and Anna Meyer left home but had to return after forgetting their tickets. Mary Carroll could not attend and gave her ticket to a friend—who perished. Otto Sass had a very restless, sleepless night before the picnic, and overslept the next morning. John Krall stopped to buy some cigarettes. (He would comment later, in jest, that "smoking had saved my life.") James Farrell stopped briefly in a store to buy some cigars. One woman discovered that her hem had to be stitched and took a little extra time. Another woman had bought a beautiful blouse to wear to the picnic but mislaid it and couldn't find it, which delayed her long enough to miss boarding. Two friends of Anna Gay stopped to pick her up for the excursion and picnic. Anna's mother was afraid and would not let her daughter go on the picnic. Many others had their own personal stories, some with a fortunate ending, others with an unfortunate ending.

A policeman holds a water-logged teddy bear recovered from the bowels of the ship by a diver. This teddy bear was likely held by a youngster bubbling over with excitement about the excursion and picnic. Not even the innocence of children was spared, as the *Eastland*'s capsizing did not show any favorites. (Courtesy Chicago Historical Society, *Chicago Daily News* negatives collection, DN-0065015.)

Jaroslav Sklenicka, a foreman at Western Electric, planned for his entire family to attend the Western Electric employee picnic. His wife and children, however, were very sick with the flu and stayed home. Jaroslav was going to stay home with his family, but his wife, Anna, urged him to go to the picnic and enjoy himself, since he was the only member of the family who was feeling well. Jaroslav did not return from the picnic. (Courtesy *Eastland* Disaster Historical Society.)

The morning of the picnic was not a very pleasant one for Erich Krueger (standing in front of the grocery wagon). He and his wife, Clara, had a terrible argument over whether or not she should go on the *Eastland* with him. She really wanted to go, but Erich said that he would be too busy working—he was a musician in Bradfield's Orchestra, a band playing on the *Eastland*. Clara stayed home, and Erich, who was on one of the lower decks when the *Eastland* rolled over, died. He was 22 years old and had been married to Clara for only nine months. Erich was not the only member of his family who was downtown that morning. His sister, Ella, and her girlfriend went down to the wharf and tried to board the *Eastland*. They waited in line but never got on. (Courtesy Lynn Sikora, grandniece of Erich Krueger.)

This young student (front row, second from left) worked at Western Electric during the summer of 1915 and planned to play in the baseball game at the picnic. He was delayed that morning and arrived too late to board the *Eastland*. This fortunate bit of fate guaranteed the future of the Chicago Bears and the National Football League—the young student's name was George Halas. (Courtesy Chicago Historical Society, *Chicago Daily News* negatives collection, SDN-0008471.)

Paul and Louise Janhke had been married just six weeks. The night before the picnic they expressed fear that something would happen to the boat. Later that evening, they stopped at their landlord's apartment and gave their landlord the key to their apartment along with $50 to be given to Paul's mother in the event they didn't return from the trip. The newlyweds both perished aboard the *Eastland*.

Josephine (Josie) Markowski told her friend's mother that she felt something awful was going to happen, and that she did not want to go to the picnic. Her friend's mother told her to "go on and have a good time." Josephine died. She was the only financial support for her father, mother, and four young brothers and sisters.

In some cases the difference between surviving or perishing was the slimmest of margins. James and Minnie (left) Rylands were on the *Eastland* with their son John (right), who was

almost four. When the boat rolled over, James could only save one member of his family. He grabbed his son and when he turned to rescue his wife, she was gone. She drowned. The Kelly family had seats on the second deck of the *Eastland* with the Thyer family. The Kelly children (Jenny, 9, and Charlie, 5) sat with the Thyer children (Helen, 9, and Harry, 7). When the *Eastland* rolled over, the entire party of eight was thrown into the river. Jenny Kelly survived although Helen Thyer drowned. The two young girls had been holding hands as they were thrown into the water. (Courtesy Joan Schroeder, daughter of John Rylands.)

In Memory
of
Nellie Latowski
Born September 4th, 1887
Died July 24th, 1915

In Memory
of
Walter Latowski
Born June 4th, 1891
Died July 24th, 1915

Agnes, Walter, and Nellie Latowski, ages 22, 24, and 26, respectively, were on one of the interior decks of the *Eastland*. Agnes left her brother and sister to take a purse to the women's lounge area. She survived, although her brother and sister both drowned. In a similar scenario, Charlie Goyette, 16, carried a handbag, which held his family's bathing suits, towels and other odds and ends, to the cloak room to have them checked. His fate was just the opposite of Agnes Latowski—he died, although the others in his party survived. (Courtesy *Eastland* Disaster Historical Society.)

Clara Milcheski survived the *Eastland* Disaster, even though she could not swim. Her best friend, an excellent swimmer, drowned.

Vaclav (James) and Zofie Homola took their two daughters, Marenka (with flowers) and Vlasta on the picnic. Father, mother, and both daughters were thrown into the river, with Marenka grabbing onto her father's neck and holding on for dear life. The family fought desperately for their lives. Father and husband Vaclav and young Marenka survived, while Zofie and Vlasta perished. Marenka never went into the water or on a boat again. NOTE: Marenka was one of the last known survivors of the *Eastland* Disaster. Known as Marie, she passed away on February 21, 2003 at the age of 91. (Courtesy Carol Gilchrist and Loretta Laughlin, daughters of Marie (Homola) Hrabacka.)

Augusta Houillon survived only because a large locker fell over her and provided an air pocket and protection from the falling debris. Like Marenka, she never went on a boat or in the water again.

John Thomas and Gabrielle Schlentz were engaged to be married. Gabrielle perished on the *Eastland*, as did John's sister Rose Thomas. John attended the funeral of his sister on Wednesday, and sat in the same seat in the same pew for his fiancée's funeral on Thursday. Gabrielle's father was convinced that if his daughter had known how to swim, she might have been able to help herself. The following summer, he started taking the family to Cedar Lake, Indiana, so that the children could begin to learn how to swim and at least get comfortable with water, even if they only learned how to tread water. Several years later, he started taking the family to Lake Geneva, Wisconsin. Tom Chakinis survived the tragedy and never forgot it. His reaction to the tragedy was opposite that of Mr. Schlentz: Tom never went on a ship again and forbade his children from going near water. (Courtesy family of Gabrielle Schlentz.)

The tragedy devastated many young couples who planned to spend their lives together. William Sherry, 22, and Emma Samek, 18, were engaged to be married—both perished. Their families had them buried together at Bohemian National Cemetery, even though they hadn't yet married. Karl Stahlik, 24, and Blanche Rudczka, 20, were engaged to be married—both perished. Their families had them buried together at Resurrection Cemetery in Justice, Illinois. E. Mary Manthey, 22, and James C. Justin Jr., 20, were engaged—they perished. They were buried together at Concordia Cemetery in Forest Park, Illinois. Elizabeth Mueller lost her fiancé, Charles Zitt. She never married. (Courtesy *Eastland* Disaster Historical Society.)

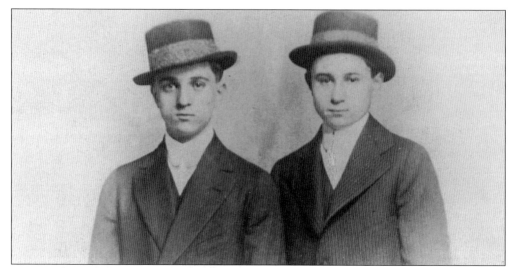

Roberto Fornera (left) planned to attend the picnic with his girlfriend. He also planned to "pop the question" when they got to the picnic grounds, asking her to become his betrothed. Roberto's family greatly anticipated the end of the day when they would all gather around the table to share in the excitement of Roberto's engagement. That time never arrived as Roberto perished on the *Eastland*. (Courtesy John Bicego, nephew of Roberto Fornera.)

Emily Bechman worked at Western Electric where she met and married Frederick Biehl. And even though they both worked for Western Electric, Emily did not join her husband for the excursion and picnic because she did not like the idea. Frederick died on the Eastland. Emily, a bride at 18, was a widow at 19.

William Guenther, 23, was unsure about attending the picnic. He had just returned from a vacation and was to work that day at his job at a store in Melrose Park. But his friend, a Western Electric employee, invited him and said, *'Come on, Willie, we'll have a good time.'* The last time Willie was seen alive was when he boarded the suburban train for the trip downtown. His brother, Adolph, identified his body at the makeshift morgue. Among the personal effects Willie carried with him that day were his pocket watch and (now water-stained) wallet and identification card. Although Willie died in 1915, his memory lives on generations later. One of his nephews was named after him, and his pocket watch and wallet appear in displays at libraries and museums throughout the Midwest. (Courtesy Mrs. George (Nadine) Kelm, grandniece of William Guenther.)

George E. Schmidt, a popular young man from Baden, Ontario (Canada), was born on July 24, 1879. He left Baden in 1902 for Chicago, where he worked as head bookkeeper at the Western Electric Company. George had originally planned to spend his birthday elsewhere, but was on one of the managing committees conducting the Western Electric employee picnic. George died on the ill-fated *Eastland* on his 36th birthday. (Courtesy of Bill Gillespie and Wendell Bark, grandnephews.)

The Plamondon family was pursued by fate. The *Eastland* Disaster claimed the life of Susan Plamondon. Months earlier, Susan's cousin by marriage, Charles Plamondon, and his wife perished while on board the *Lusitania*. Years earlier, Emily Plamondon and her cousin Charlotte E. Plamondon (daughter of Charles) survived the Iroquois Theatre Fire.

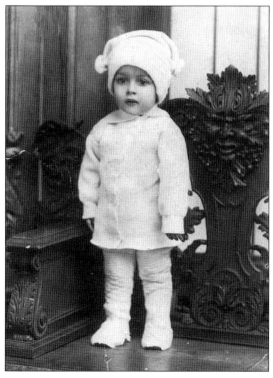

Martin Pisano, a Western Electric employee, was 23 years old and married. His son Salvatore (Sal), who was just 3 months old, was in his mother's arms at the wharf as his father boarded the *Eastland*. It would be the last time that mother and son would see their husband and father. To assist the families of employees who had lost their primary provider, Western Electric hired the family members of the victims, giving preferential treatment to them. Adolph Pisano applied for one of these jobs, listing Martino Pisano as his brother. This was simply a ploy to get a job—Martin Pisano did not have a brother named Adolph—he had no brothers at all. (Courtesy Sal Pisano.)

Several events in the years before the tragedy may have prevented disaster altogether, or at least from occurring in Chicago. Two years prior to the opening of the 1915 World's Fair (Panama-Pacific International Exposition), a form of entertainment other than bi-planes was considered for the tourists who would attend the Expo. Several San Francisco area businessmen pursued a deal to purchase the *Eastland*, intending to use it for excursions around the San Francisco Bay during the Fair. The deal fell through due to tight finances, and a potential catastrophe in San Francisco (instead of Chicago) was avoided. While the deal was still being considered, a San Francisco marine architect inspected the *Eastland*. This ship designer felt the *Eastland* was safe in any waters as long as the ballast tanks were full. Unfortunately for those living in Chicago in the summer of 1915, the *Eastland's* ballast tanks were not full on the morning of July 24. (Courtesy *Eastland* Disaster Historical Society.)

As an ancillary footnote, the opening day festivities for "Illinois Day" at the Expo were scheduled, coincidentally, for Saturday, July 24, 1915. Just a few hours before the official ceremonial kickoff, the *Eastland* rolled over in Chicago. When news of the disaster reached Governor Dunne and Mayor Thompson in San Francisco, they immediately changed their festive "Illinois Day" welcome speeches to interludes of grief. The "Illinois Day" festivities were cancelled, and the two dignitaries from the state of Illinois promptly returned to their home state. (Courtesy *Eastland* Disaster Historical Society.)

A more glaring example of how the *Eastland* Disaster may have been avoided was the letter sent on August 3, 1913 by naval architect John Devereux York to the United States Harbor Master. It read: "You are aware of the condition of the S. S. *Eastland*, and unless structural defects are remedied to prevent listing—there may be a serious accident." The letter, tragically, received no response and was ignored.

In another case, William Bodine, Superintendent of Compulsory Education, submitted a report to the Board of Education a year before the disaster. Although it didn't specifically mention the *Eastland*, it read, in part: "Our investigation shows that the average lake excursion boat is frequently crowded to the rail on weekend trips and holidays. Personal safety on overcrowded lake excursion boats is a risk of life in which humanity must depend upon fate as to whether it will be numbered among the lost or the saved, and many women and children will someday pay the tragic penalty of overcrowded boats and lack of adequate life-saving facilities. I recommend that the lake excursions of the vacation schools be abandoned. It is only a question of time when there will be a disaster on one of these excursion boats that will stagger Chicago." (Courtesy Earl Gallas.).

Questions were raised regarding the known instability of the *Eastland*, right up to the day before the disaster. Cornelius Coughlin (seated in light jacket) and sons, Leonard and Norman, took the Chicago-to St.-Joseph excursion on the *Eastland* on July 23, 1915. Twenty miles out into Lake Michigan, the ship reportedly listed some 20-plus degrees to port very suddenly, causing consternation among some passengers. The list prevailed for about two or three hundred feet as the ship held the list before righting itself to an even keel. A church group was rudely divested of their meal—stuffed olives, tiny sweet gherkins, and gobs of potato salad wound up on the deck. The ship was stable for the remainder of the journey to St. Joseph, as well as the return trip to Chicago. The photo was taken 18 hours before the disastrous sinking of the ship on the Chicago River. Eva Burchill similarly reported that a friend, who had taken a lake cruise on the *Eastland* the day before, said that it listed noticeably. She added that "this was considered fun by the passengers."(Courtesy family of Norm Coughlin.)

Perhaps what comes the closest to expressing the indescribable nature of the tragedy is the story of Emma Schroll. Emma and her husband, Julius, both worked at Western Electric, as did Emma's two sisters, Anna and Paulina Straka. All four boarded the *Eastland*—and perished. (Courtesy *Eastland* Disaster Historical Society.)

Emma Schroll's body was misidentified as Miss Margaret Morgan and placed in the parlor at the Morgan home to await burial. Meanwhile, Emma Schroll's family mistakenly claimed as Emma the body of another young woman, that of Miss Emma Meyer. Three bodies—two mistaken identifications. By the time the first of the two misidentifications was discovered, one of the three girlís bodies had already been buried, thereby preventing the proper and timely identification of two of the girls. The mix-up was resolved nearly one month later when the body in Emma Schroll's grave was exhumed and identified as Emma Meyer: The body had a mole on the shoulder and a scar on the forehead, just as Emma Meyer's family had described to the coroner's office. (Dental records later confirmed the identification.) On August 19, Emma Schroll became the last victim of the Eastland Disaster to be identified and buried. Not one but two errors had been made by the grieving families in identifying her body. (Courtesy Eastland Disaster Historical Society.)

Ten
OUT OF OBSCURITY

"History is the ship carrying living memories to the future."—Stephen Spender

The day after the disaster, the *Chicago Tribune* and other local newspapers accurately described the significance of the *Eastland* disaster as the "most appalling and horrifying catastrophe in history of inland navigation," "an unparalleled tragedy," and the "most colossal tragedy in Chicago's history." Yet as the days, weeks, and months passed, the memory of the tragedy faded. And by the time the years and even decades had passed and the courts had finally issued their verdicts, the memory of the tragedy was completely buried. It was almost as if a big black hole had been punched in the collective consciousness of Chicago. Recent newspaper headlines differed significantly from those in 1915, calling the *Eastland* Disaster "a case of social amnesia," "all but forgotten," and "a tragedy lost in history." Why is the *Eastland* Disaster part of individual memories yet not part of our culture? How could something so tragic have become so obscure? Fortunately, the first 75 years of repressed memory are being undone. There has been a recent resurgence of the memories of the *Eastland* Disaster, such that the tragedy will always be remembered as Chicago's greatest (not worst) tragedy.

Memorial cards of various sizes and designs were printed and issued to the victims' families. This memorial card is of *Eastland* Disaster victims Mrs. James (Zofie) Homola and her youngest daughter Vlasta. The poem on the inside read:

"Sleep on, sleep on, thou pulseless heart,
 Where jasmine stars drop golden rain,
 From every troubled thought apart,
 Forgotten every earthly pain.
 Sleep on; thy long repose is sweet,
 Tender and cool thy grassy sod.
 O traveller! Stay thy hurrying feet;
 Step softly here—'he rests in God.'"

(Courtesy Carol Gilchrist and Loretta
Laughlin, daughters of
Marie (Homola) Hrabacka.)

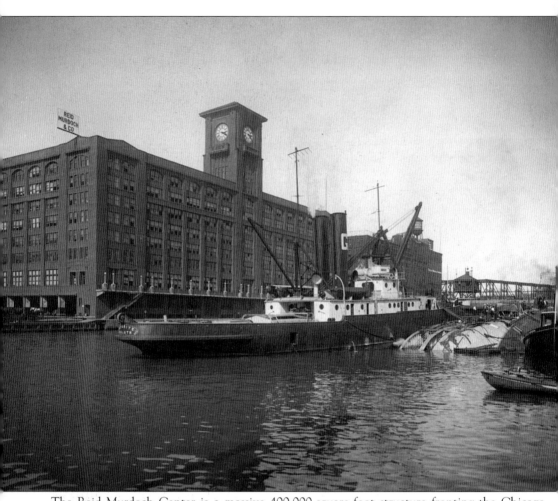

The Reid Murdoch Center is a massive 400,000-square-foot structure fronting the Chicago River between LaSalle & Clark Streets. It was built as a central food processing plant for Reid, Murdoch & Company. Designed by George C. Nimmons of Chicago (a student of Daniel Burnham), the building was one of the first structures to be erected (in 1913) in full accordance with Burnham's vision that the Chicago River should serve the City much as the Seine serves Paris or the Thames serves London. It is on the National Register of Historic Places and is a Chicago landmark for those reasons, as well as its architectural integrity. In 1915, the building towered over the scene as the *Eastland* Disaster unfolded. Today, it continues to overlook the site where nearly 850 people died—Chicago's greatest tragedy. Chicago policeman John B. McFarlane, sitting in the Chicago River & Harbor Patrol boat in the right foreground, aided in the rescue and recovery efforts. (Courtesy of Betty Hogeorges, daughter of John B. McFarlane.)

In 1998, the *Eastland* Disaster Historical Society was formed. The only organization dedicated exclusively to the *Eastland* Disaster, the society is transforming the way that history education is taught, learned, and shared by providing education and information regarding the *Eastland* Disaster. The organization also commemorates those families whose lives were affected by the tragedy. The story, after all, and as the logo suggests, is not about a ship. Rather, it is about people—the tens of thousands of people whose lives were affected in various ways by the *Eastland* Disaster. To share your family's story with the society, contact them on the Internet at http://www.EastlandDisaster.org or by toll free phone 1-877-865-6295. Inquiries may be addressed to: The *Eastland* Disaster Historical Society, PO Box 2013, Arlington Heights, IL 60006. (Courtesy *Eastland* Disaster Historical Society.)

For nearly 75 years, a marker of any sort did not exist to commemorate the site of the *Eastland* Disaster. That changed in June 1989. Led by teachers Bernie Hollister and Bill Stepien, a group of students from the Illinois Mathematics and Science Academy (Aurora, Illinois) worked with state officials to erect a historical marker at the site of the tragedy. The marker, originally located along the north side of Wacker Drive between Clark and LaSalle Streets, was re-cast and, in July 2003, re-dedicated. The marker today is located prominently on the northeast corner of Wacker Drive and LaSalle Street, overlooking the exact site of the *Eastland* Disaster. (Courtesy *Eastland* Disaster Historical Society.)

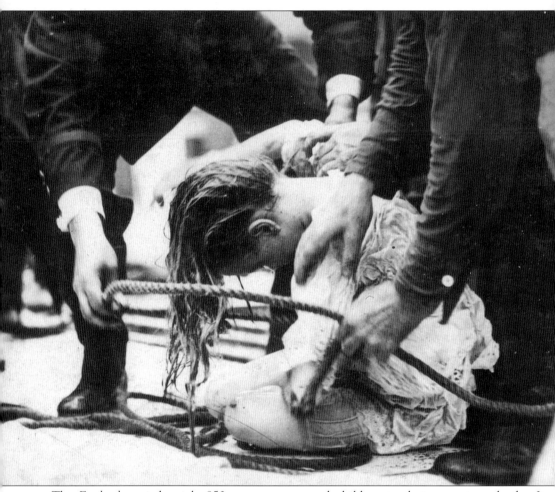

The *Eastland* carried nearly 850 men, women, and children to their premature deaths. It affected thousands more. It was a disaster that was too horrible to comprehend. Mr. Charles Kelly perfectly described the *Eastland* Disaster the day after surviving the tragedy: *"You might close your eyes and try to imagine the scene, but you could not stretch your imagination far enough to cover it as it really was; to be in it is the only way one can realize the enormity of it."* (Donated by Lynn Steiner; courtesy *Eastland* Disaster Historical Society.)